Armijo High School

Fairfield, California

TONY WADE

Published by The History Press
Charleston, SC
www.historypress.com

Copyright © 2023 by Tony Wade
All rights reserved

Front cover, clockwise from top left: Armijo grads in their caps and gowns. *2007 Armijo yearbook*; the Armijo Super Band. *1974 Armijo yearbook*; Pat Morita with his 1949 Armijo yearbook. *Courtesy of Art Engell*; the second Armijo High School building on Union Avenue. *Tim Farmer collection.*
Back cover, top to bottom: A school bus in front of the Armijo gym. *1982 Armijo yearbook*; Armijo's California Distinguished School banner in 1988. *Tim Farmer collection*; the Armijo student parking lot with painted messages from seniors. *1982 Armijo yearbook.*

First published 2023

Manufactured in the United States

ISBN 9781467154642

Library of Congress Control Number: 2023934778

Notice: The information in this book is true and complete to the best of our knowledge. It is offered without guarantee on the part of the author or The History Press. The author and The History Press disclaim all liability in connection with the use of this book.

All rights reserved. No part of this book may be reproduced or transmitted in any form whatsoever without prior written permission from the publisher except in the case of brief quotations embodied in critical articles and reviews.

*To the faculty and alumni of Armijo High School
from the distant past and long into the future.*

CONTENTS

Preface: Creating the Mosaic 7
Acknowledgements 11

Chapter 1. The Early Days and School Buildings 13
Chapter 2. Student Life Through the Years 31
Chapter 3. Teachers and Faculty 56
Chapter 4. Student Stories 73
Chapter 5. Athletics 104
Chapter 6. The Armijo Super Band 136
Chapter 7. Armijo School Newspapers and
 La Mezcla Yearbooks 142
Chapter 8. The Armijo Centennial and the
 Armijo Alumni Association 156
Chapter 9. The Indian Symbol 160

Epilogue: Beyond Pomp and Circumstance 167
Appendix A: Who Was Your Favorite Teacher at Armijo? 169
Appendix B: Odds and Ends 171
Appendix C: Armijo High School Timeline 175
Appendix D: The Armijo High School Hall of Fame 187
Appendix E: Armijo High School Principals 189
Bibliography 191
About the Author 192

Preface

CREATING THE MOSAIC

Numerous motion pictures over the years have attempted, with varying degrees of success, to reflect the American high school experience. One of the most popular subgenres is of amazing teachers who break through students' near-impenetrable cool barrier to become classroom superheroes. They include *Blackboard Jungle*, *Stand and Deliver*, *Freedom Writers* and many others.

Then there are those films that are laser-focused on a particular era and include cultural touchstones dripping with nostalgia, like *American Graffiti* and *Dazed and Confused*. There's no shortage of films about young people navigating the headwaters and breakers of being a student athlete, such as *Love and Basketball*, *Friday Night Lights* and *Coach Carter*.

Adolescent romantic relationships have been explored in films like *Fast Times at Ridgemont High*, *Easy A*, *Cooley High* and more. Then there are those that depict the oftentimes rigid and cruel teen hierarchical structure present in many schools. Examples are *Mean Girls*, *Sixteen Candles* and the quintessential statement on the topic, *The Breakfast Club*.

Now, art does sometimes imitate life accurately, but more often than not, films caricature rather than capture that special coming-of-age period from freshman to senior years. That's because trying to encapsulate so much of what the high school experience can entail in a mere two hours is a nearly impossible task. That's why cinematic storytellers present a sliver, a representative sample to focus on.

Preface

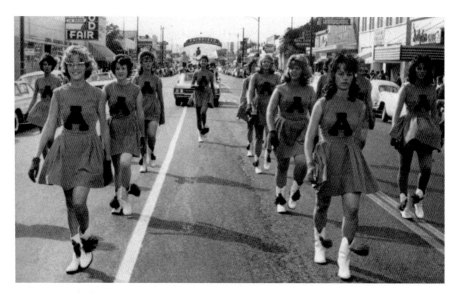

The Armijo Pow Wow Drill Team under the direction of Ms. Meek marching in downtown Fairfield. *1964 Armijo High Yearbook.*

I had that same mindset when preparing to write this book. There is simply no way to comprehensively squeeze over 130 years of teachers, students, homecomings, sports, clubs, dances, yearbooks, graduations and so much more into a mere two hundred pages. This is not an almanac or an encyclopedia.

My goal going in was to do my absolute best to capture the flavor of Armijo High School over its lifetime. I have highlighted historical markers, showcased representative profiles of some of the faculty and students and presented topical touchstones.

Even before this book was even close to being completed, I was already envisioning alumni at my bookselling and signing events thumbing through copies and asking me, "Why isn't so-and-so mentioned?" and "What about this or that?"

Here's the thing: This is not *the* history of Armijo High School. It is *a* history of Armijo High School. I liken it to an artist creating a mosaic. It's up to the artist to choose what little pieces can make the bigger picture they are hoping to express.

The students, faculty, sports teams and more that I have covered are those I thought could best achieve that goal. If I didn't mention a person or a topic, it's not meant to be a slight or to suggest they were not worthy. What I cover in this book are my choices, and I stand by them. Lyrics from the

Preface

A serene view of the Armijo campus. *1980 Armijo High Yearbook*.

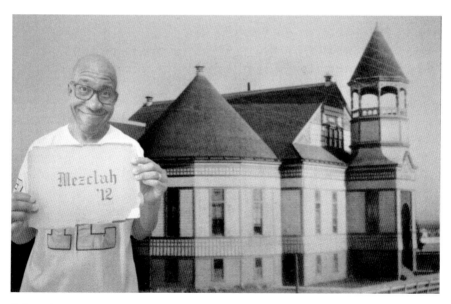

A "genuine unretouched" photo of Tony Wade standing near the original Armijo High School building holding a copy of the first *La Mezcla(h)*. *Tony Wade*.

Preface

old Ricky Nelson song "Garden Party" come to mind: "You can't please everyone, so you got to please yourself."

A criticism about my first book, *Growing Up in Fairfield, California*, that I heard from some Fairfield High School grads is that it was very Armijo-centric. I plead guilty as charged. As the saying goes, "You write about what you know." Truth be told, I now wish I hadn't included so many stories of Armijo grads, because some of the more famous people (like Noriyuki "Pat" Morita and Johnny Colla) must also be in this book.

I decided to not limit the "Student Stories" chapter to celebrities or people who made a huge impact on society. I also wanted to include interesting people with tales that may not be as well known.

Since I am a past president of the Armijo Alumni Association and have been writing a local history column for years, getting access to relevant materials to launch this project was the (relatively) easy part. The real work was creating the mosaic.

This book is not about me, it's about Armijo. But in two instances I have taken the liberty and license to include my personal feelings and thoughts. They are about Matt Garcia and about the Indian symbol.

My hope is that you, dear reader, find something here that you didn't know, come across an interesting story or anecdote to sink your teeth into or, at the very least, from time to time experience the delightful soul tickles we dub "nostalgia."

I hope you enjoy the ride.

—Tony Wade
April 1, 2023

ACKNOWLEDGEMENTS

It's a true blessing to be married for more than twenty-eight years. When you're a writer, it's a bonus having a spouse, like my wife, Beth, who is an excellent editor.

I never had the pleasure of meeting teacher and local historian Tim Farmer, but having access to the materials that he accumulated during his life has proved to be invaluable. I have met another Farmer (no relation) I need to thank: former sports editor of the *Daily Republic* Paul Farmer. His past articles on local sports teams and athletes were a huge help.

Fist bumps to The History Press for their encouragement and help in this project and in my previous two books. Thank you to all of the folks I interviewed for this book and the ones who posted comments on Facebook.

Thanks to all the businesses and organizations that allowed me to have bookselling and signing events for my previous works.

Most of all, thanks to all of my faithful readers.

Chapter 1

THE EARLY DAYS AND SCHOOL BUILDINGS

A School Is Born

When stacked up against other notable events of 1891, such as the founding of the Wrigley chewing gum company in Chicago, the publication of the first short story featuring British author Arthur Conan Doyle's character Sherlock Holmes or the invention of the game of basketball by James Naismith in Massachusetts, the founding of Armijo High School in little ol' Fairfield, California, may pale in comparison. But it sure didn't pale to locals.

In August 1891, an announcement in the *Solano Republican* newspaper read: "ELECTION NOTICE! Notice is hereby given to the qualified electors of a Union High School District to be composed of Dover, Gomer, Union, Fairfield, Crystal, Green Valley, Rockville and Suisun School Districts, Solano County that an election would be held on August 29 for the establishment and formation of a Union High School District."

The lobbying for the formation of the high school in the editorial pages in the following three weeks was nearly constant. The following was published the day before the election:

> *If you are not too selfish, if you have any interest in the welfare and prosperity of your community and your children, be a patriotic citizen and drop a vote for the High School for the community, for your children and for your neighbor's children.*

A vote for the high school is money in your pocket—not only by advancing the price of your property, by bringing people of means and their trade to the community, but by saving you the enormous expense attendant upon sending your children away to complete their education.

The editorial stressed that the question before the voters was simply whether the school district that residents lived in should be a part of the proposed new high school district, thereby giving all the children there the benefits of the school, free of cost. It said that all other questions that subsequently might arise would be settled by the Board of High School Trustees.

When the vote to create the new district and high school passed, the disputes started in earnest. An injunction was served on the Trustees of the Union High School, restraining them from opening. An editorial in the October 16, 1891 newspaper blasted the move: "We have no fear of the ultimate effect of injunctions as they will only prove the high school idea well-founded, but it is somewhat annoying to have obstacles placed in the way simply to gratify a whim of some fourteenth-century spirited taxpayer who has no children to educate, but forgets that he may have grandchildren and neighbors who desire high school privileges here at home."

Once that was dispatched with, another controversy reared its head: Where should the high school be located? The argument for Fairfield was made in an editorial: "It is readily accessible from all parts of the Union District. A sidewalk can be constructed from the present plank walk on Main and Union Street [*sic*] at Joice's, and thus a dry walk will extend directly to the grounds. Sheds can be erected when needed for the horse and buggy of such as come with their own conveyance." (This was perhaps the first mention of an Armijo student parking lot.)

An alternative to the Solano County seat being the site for the school was Suisun City. To modern readers, the following editorial may seem just a tad over the top in its tone, but at that time, Suisun City was a much larger and more robust community.

In all things but education this community is fairly apace with others. If now these Trustees will act wisely and give this school the best possible location for its future prosperity, it will stand a beacon light to our more benighted neighbors and we shall fully exonerate ourselves for our past dereliction of duty towards the rising generation.

Who of these Trustees would vote to erect a fine Odd Fellows, Masonic or Native Sons hall at Manka's Corner, Rockville or even Fairfield? Who

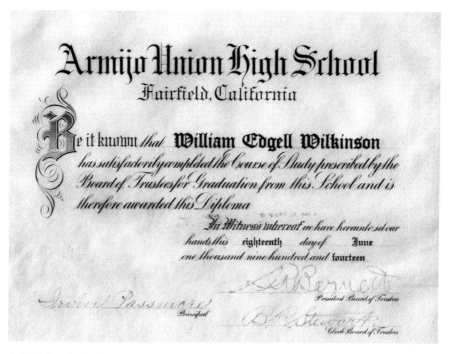

A 1914 Armijo Union High School diploma. *Tim Farmer collection.*

of you would invest your capital in a fine hotel, large store or livery stable in this district at any other point than Suisun? If you did you would be deemed unwise for such investments as naturally seek the business center as water seeks its level: and for the same reasons, should the high school be similarly located.

It would be accessible from three directions by rail, and we may reasonably prophesy that if this school prospers, as it certainly will if properly supported by its intelligent patrons, it will receive a good support from pupils without the district and relieve an imaginary grievance of a burden of taxes.

I would say then to you, Trustees, do not erect a monument of folly by giving this school other than its natural location, for such an act would be little less than criminal.

Spoiler alert: The trustees chose Fairfield to build their criminal "monument of folly."

A sour grapes response was published in the September 1, 1891 newspaper: "I note that the High School is to be located in Fairfield. While this place

is far superior to Rockville, it is a shame that petty jealousies should have deterred the Board of Trustees from placing it in the town of Suisun. They will no doubt pay penance for their error in future years."

Perhaps the penance Armijo paid (and, as of this book's publication, is still paying) is not winning a football championship since 1936.

Who Was Armijo?

If there was a dispute about what to name the new high school, that information did not make it into the available historical record. But there is current-day confusion about its origins.

When the debate over whether or not to change Armijo High School's symbol/mascot/logo heated up and reached its peak in 2019, with locals coming in hot to weigh in on the topic on social media, one thing became very clear: A lot of people, on both sides of the issue, had absolutely no idea who Armijo was.

Let's start with who or what Armijo was not. Armijo was not the name of a tribe of local indigenous people. "Dr. Armijo" did not found the school. The waving Chief Solano statue that has stood sentinel over the old county library building (now the County Events Center) since 1938 is not "Chief Armijo." Nor was the likeness of the Indian from the cover of the 1987 *La Mezcla* yearbook that was reproduced on the side of the school's gym facing Texas Street in 1988. There was no Chief Armijo.

Jose Francisco Armijo, by birth a Mexican, was a traveling merchant who sold mainly hides and brandy. In 1830, he pioneered a trade route that connected Santa Fe, New Mexico, and Los Angeles, California that came to be known as the Old Spanish Trail and the Armijo Trail.

Despite being characterized as the "longest, crookedest, most arduous pack mule route in the history of America," the Armijo Trail was the nineteenth-century equivalent of a highway and was used by traders until the end of the Mexican-American War in 1848.

Armijo was the first to petition the Mexican government for a land grant in Solano County. On March 4, 1840, he and his son Antonio Mariano were given the Tolenas Land Grant. It covered the northern part of the Suisun Valley, extending east from the shores of Suisun Valley Creek toward the Cement Hill region and then south. The 13,315-acre grant was named after the Tolenas Indians, who once occupied the area.

The Early Days and School Buildings

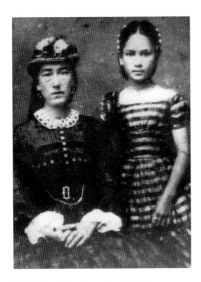

Mrs. Jose Francisco Armijo (Jesus Maria) and her granddaughter Maria Armijo, daughter of Antonio Mariano Armijo. *Tim Farmer collection.*

Armijo's neighbors were Chief Solano, who owned the Rancho Suisun grant, and Armijo's cousins Manuel Vaca (for whom Vacaville is named) and Juan Felipe Peña. Armijo was given permission to occupy the land immediately. Commandant General Vallejo noted on the margins of the letter that he should try to cooperate with the Indians still living on the land, inspire them with confidence in the settlers and, should any rebellion occur, immediately communicate with Chief Solano.

The Armijos, Vacas, Peñas, Berryessas and other transplanted families built adobe houses, raised cattle and crops and prospered in the Solano County area.

But there were problems. One of the main issues was property boundary disputes. It turned out that using vague descriptive markers like "an entrance to a bear's cave" or "a clump of dogwood" and just eyeballing inaccessible areas like swamps wasn't the best idea. The disputes were brought to court, but when legal justice was slow in the offing, frontier justice sufficed.

In 1849, Jose Francisco Armijo died unexpectedly of pneumonia and was followed shortly thereafter by his wife and by his eldest son, Antonio, the following year. The legal fight to keep their land was waged by Jose Francisco Armijo's descendants for many years, but eventually, they sold off what they owned, and the last surviving son, Jesus Armijo, died unmarried in Fairfield in 1906.

In the early 1900s, a rumor spread like wildfire that Jose Francisco Armijo had secretly buried some Mexican gold on his property. A mini–gold rush began. The property was honeycombed by parties in search of the hidden coin. If anyone found it, they kept it hush-hush from recorded history.

Much of what made Jose Francisco Armijo the choice to be the namesake for the new Fairfield high school is not readily available in the historical record, but poet Edwin Markham, who grew up in Lagoon Valley, wrote an obituary for the pioneer twelve years after his death that shows he was highly thought of.

An artistic likeness of Jose Francisco Armijo's son Antonio Mariano Armijo. *Tim Farmer collection.*

He was one of those rare spirits that the years could not touch with age—a being that never outgrew the eager heart of boyhood. He seemed ever to live on some shining tract above the commercialisms and conventions of the world. If he ever did go further along the common way, it was as a romantic youth finding the rose of life well worth the hidden thorn. He cheered the

road for all who traveled it, leaving friends at every parting of the ways. All hearts will wish him fair fortune on the uncharted trails where he now seeks new scenes to explore under stranger and fairer stars.

The First and Second Armijo High Buildings

After the dust settled on the argument about the school's location, the very first Armijo High School was started in 1891 with thirty students in a single classroom located on the second floor of the Crystal Elementary School building. So, at least temporarily, Armijo *was* located in Suisun City, as some had argued for—until a proper schoolhouse could be built.

In 1893, the first Armijo Union High School building, located on Union Avenue on land donated by Fairfield founder Captain Robert Waterman, opened for students. The wooden structure featured classic Queen Anne, Victorian-style architecture with asymmetrical exteriors and decorative trim and came complete with an elegant bell tower, carpenter gothic decorations and fish-scale shingles.

Several period photographs attest to the beauty of the first Armijo building. Great pride was shared among locals who had labored to make the dream of a Fairfield high school a reality. But by 1907, the bloom was off the rose.

That year, the December issue of the school newspaper, the *Armijo Student*, featured an editorial, "A Plea for a New High School Building." It began with a description of some of the more egregious problems students had to contend with. "Our school is at one end of the Union district, on the main street about one hundred and fifty yards from the railroad and across from the county jail. We often have to listen to the prisoners' songs. The slaughterhouse is just to the north of us and when the north wind blows we get the full benefit. Some may say 'Well, the north wind doesn't blow very often.' Perhaps it doesn't, but a week never passes unless we receive some gentle reminder of its existence."

Evidently, according to the editorial's writer, the stately and handsome exterior of the school was not matched by appropriate design considerations in the interior. The corridors, instead of being light and airy, were dark, cold and gloomy. The library and English class were combined—when someone was giving a recitation, they were constantly being disturbed by others seeking reference books. Students also had to pass through one classroom to get to another.

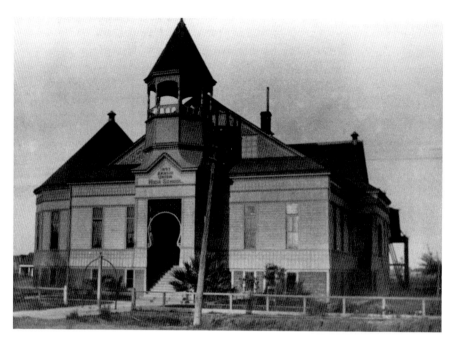

The original Armijo Union High School building on Union Avenue opened in 1893. *Tim Farmer collection.*

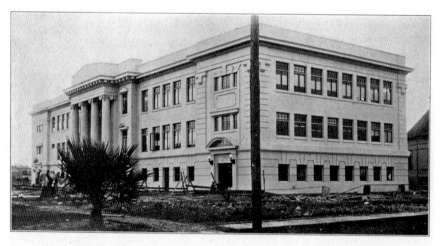

The then-new Armijo Union High School building. *1915 Armijo High Yearbook.*

Then there was the issue of heating the building during the winter. "Many days during the winter months the temperature of the rooms is not fifty-five degrees Fahrenheit. Our furnace simply will not heat the building properly, but it can smoke it to perfection. More than once our school has had to be dismissed on account of the smoke."

The writer described the grounds outside the building as "dingy" and "hideous" before bringing it home: "In the light of the practical, pressing needs, I will not mention the lack in furnishings, ornaments and surroundings usually considered part of the necessary equipment of the modern school building such as a lunch room, reading room, gymnastic and athletic grounds. Such are the serious defects in the present building and its site. Surely no one can deny that these should be remedied immediately and that remedy lies alone in a new school building."

In 1913, a fire hastened calls for a new building. A successful $70,000 bond election that same year got the ball rolling, and construction of the new school building, directly in front and to the left of the original, began in earnest.

The sixteen-thousand-square-foot majestic, reinforced concrete building echoed the neoclassical style of the courthouse across the street. With a price tag of $85,000 (approximately $2.5 million in 2023), the new building opened to students on January 4, 1915, and was officially dedicated on March 14.

The new school was viewed as a masterpiece and was awarded a prize at the 1915 San Francisco World's Fair. It not only had several features its predecessor did not, including a gymnasium, study hall and physics and chemistry laboratories, but it was also home to the Solano County Free Library. Students' daily treks to and from school also became easier in the winter, as the Fairfield streets were finally paved that year.

The 1929 Fire

What possible reason could Allan Witt—a barber in Fairfield for sixty-eight years, a city councilman and mayor for more than two decades and a champion of local youth (resulting in West Texas Street Park being renamed in his honor)—have to be throwing rocks at a building on Union Avenue in order to break out the windows?

Well, that particular building was the Armijo Joint Union High School, and Witt, then sixteen years old, along with other students, was chucking rocks at the third-floor windows to break them so firefighters could get water inside to help extinguish the fire that broke out on December 8, 1929.

The blaze was discovered by Principal/Professor James Brownlee and Athletic Director Carrol "Buck" Bailey at 12:45 p.m. The alarm was sounded, and Fairfield fire chief Matt Knolty and his firemen were on the scene in less than a minute. The firehouse back then was very close to the school, right on the corner of Texas and Jefferson Streets, near the fountains in front of the current Solano County Government Center building.

Despite the extraordinarily quick response, the fire was already raging out of control. Compounding the difficulty of the firefight was the fact that the Fairfield Fire Department did not have ladders long enough to scale Armijo's high walls. Exploding chemicals in the chemistry room added to the fury of the flames, and the roof caved in.

When the fire was finally out, the heavy concrete walls of the structure were all that remained, as the interior was made of wood. The Solano County Free Library was a total loss. Its insurance was $15,000, but the loss was ten times that amount. After the fire, the library moved to the Veterans Hall in Suisun City and, in 1931, had a new home across the street from the high school.

The origin of the fire was at first attributed to faulty wires. But on December 11, Napa fire chief C.F. Otterson, who had helped in the effort to combat the Armijo fire, emphatically stated to members of the Fairfield Lions Club that the cause was arson. He said the fire was started in the attic directly over the main entrance using a slow-burning torch, which ignited the ceiling in the attic.

The evidence for the fire being of suspicious origin was bolstered by other facts. On the same day of the Armijo fire, the Catholic church in Rio Vista also burned. Some felt that school and church fires in Ukiah, Mendocino, Kelseyville, Vallejo and Oakland in rapid succession after the Armijo blaze pointed to the sick work of a serial arsonist, arsonists or copycats. After two Oakland schools were burned by what were described as flame bombs (possibly Molotov cocktails), all of the wooden school buildings in that city were guarded by night watchmen. Napa followed suit.

When students returned from Christmas vacation, the Fairfield Grammar School, American Legion Hall, the old Methodist Church and the Suisun Community Hall were all used as classrooms until the restoration of the school could be completed.

In 1930, a $50,000 school bond was passed; coupled with the insurance money, it financed the rebuilding of the school. The local attitude was summed up in a January 1930 editorial in the *Solano Republican*: "Out of the dust and ashes of a once beautiful structure there shall be raised up

The Early Days and School Buildings

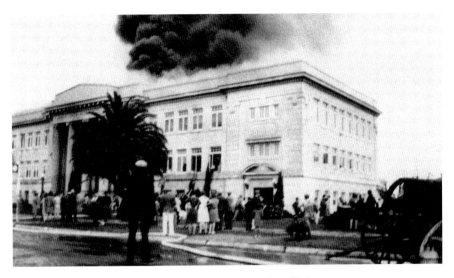

The devastating 1929 fire was seen by many as arson. *Vacaville Museum*.

a mightier, more handsome and best of all a more adequate temple of education than was thought would ever grace the valley where once Chief Solano dreamed, walked and hunted. Out of chaos there shall come order and a school building to bless the rising generation."

The editorial was not completely hyperbolic: The rebuilt Armijo *was* better, as it included an addition that would benefit the entire community: a pristine auditorium that seated approximately eight hundred people. A November 6, 1930 tease in the *Armijo Hi Lites* newspaper column touting its then upcoming dedication read that "every seat in the big theater will be 'ring side' and the stage will be the last word and a joy to the actor."

The Armijo Auditorium

On October 2, 1985, a two-ton wrecking ball destroyed the then fifty-five-year-old Armijo Auditorium. The eight-hundred-seat theater was the jewel of the community when it opened in 1930.

In 2012, Johann Klibanoff, whose brother Dr. Philip Rashid produced numerous shows with the Belfry Players at the Armijo Auditorium, reminisced about the venue. "It had red velvet drapes hanging from golden rods and beautiful windows. The acoustics were extraordinary. It had graduated seating and there was not a bad seat in the house," Klibanoff said.

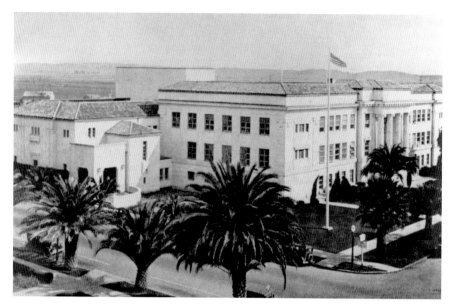

The Armijo Auditorium (*left*) opened in 1930 and was destroyed fifty-five years later when efforts to save it failed. *Tim Farmer collection.*

The auditorium was designed in a Spanish colonial revival style. It featured one main raised stage, a main floor with graduated wooden seating, an orchestra pit and a balcony. The first production at the theater was the 1917 play *Polly with a Past*, which had been on Broadway in 1929.

It became a tradition for the annual senior school play to be presented right before graduation. So, in addition to studying for finals and perhaps preparing for college, several cast members also had to memorize lines and stage blocking.

Concerts, attractions, theatrical events and other amusements presented by both local and traveling groups performed at the Armijo facility.

The auditorium wasn't used only for entertainment, however. It was also the go-to choice for large-scale community meetings. In February 1942, two months after the surprise bombing of Pearl Harbor by the Empire of Japan, a Mare Island fire official spoke there to hundreds of locals on the correct way to extinguish incendiary bombs.

Twenty years later, problems with the auditorium were detailed in a rather prophetic May 20, 1962 *Daily Republic* editorial, "Is Armijo Auditorium Doomed?" It listed many issues with the then thirty-two-year-old local landmark, including being labeled an earthquake hazard by the state.

The problems came to a head in 1963, when the city was in negotiations to sell the old Armijo High School building on Union Avenue to Solano County to use as an administrative center. The cost of refurbishing the auditorium then was about $250,000 ($2.4 million in 2023). It may have been the first time the slogan "Save Armijo Auditorium" was used in a headline. It grew into a local movement led by the aforementioned Dr. Philip Rashid, Fairfield City Council member Robbieburr Berger and others.

Although the auditorium had been the site for school and community events for decades, in 1968, it was boarded up and closed. The venue suffered a fire in 1970 and was repeatedly vandalized. Black mold was later visible on the outside of the building.

In 1972, the Fairfield Suisun Fine Arts Council formed the Save Armijo League and began to raise money to restore the auditorium to its former glory. The venue's best chance for rescue was a failed 1975 attempt to have it designated a historical site, which would make it eligible for public and private foundational grants.

The following year, Proposition H, a local measure asking Fairfielders to back up their love for the arts and longing to have a community venue by digging into their wallets, was defeated by a two-to-one margin.

In 1984, County Assessor Gordon Gojkovich led a last-ditch Hail Mary effort to somehow come up with the money to restore the building, but it failed. The wrecking ball swung the following year, and when the debris and dust were cleared, all that remained were memories.

RAY LAPOINTE: The stage and auditorium of the old theater was a trip back in time. It had footlights, a technique that was very old by the 1960s.

ALICE BEEP JACKSON WRIGHT: I sang with the Armijo a cappella choir in that auditorium. We recorded a live album there and I had a solo on the song "A Balm in Gilead."

CHUCK JOHNSON: I remember being sad when I moved back to Fairfield after being gone for a while and saw that they had torn down the theater. I could still see my name painted on the back stage wall that was now an exterior wall. That is until they painted the whole building.

CHRISTY THOMPSON: I had my first ballet recitals there in its waning days in the mid-'60s. For a long time, I thought I'd actually dreamt that it existed.

The Armijo Gymnasium

In 1953, construction of a new Armijo gymnasium began. The $500,000 structure ($5.5 million in 2023) took the place of the old gym at the Union Avenue building, which was converted into a shop for the boys. The new facility was built a block east from the campus on Union Avenue.

It was touted in a July 27, 1953 newspaper article, which made it clear who it was being built for. The first paragraph listed "young men" and "for the boys." Title IX and societal norms eventually changed that.

The 28,000-square-foot gym had a bleacher seating capacity of 1,320 people and included a 100-by-125-foot basketball court. To preserve fans' sightlines, the court featured transparent backboards.

The gym became a very visible symbol of the school even before the campus moved to Washington Street. It was the site of numerous successful basketball games by legendary Armijo High coach Ed Hopkins, and many felt it should rightly be named after him.

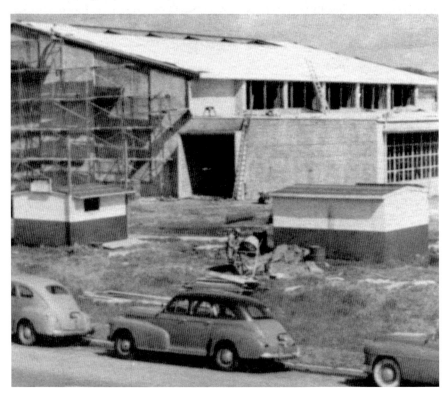

Construction of the Armijo gym on Washington Street in the early 1950s. *1991 Armijo High Yearbook.*

The Early Days and School Buildings

E. Gary Vaughn Gymnasium in 2016. *Tony Wade*.

But before that movement gained steam, the gym already had a namesake. Armijo Class of 1959 grad Eugene Gary Vaughn had started teaching government, international relations and physical education at Armijo in 1963 after graduating from the University of the Pacific in Stockton. He was also the Armijo's boys' basketball coach and athletic director until he was stricken with cancer. He died at thirty years of age on February 24, 1972, and the gym was dedicated to him in December of that year.

In addition to basketball, volleyball, wrestling, badminton and other sports, the E. Gary Vaughn Gymnasium was used for rallies, dances, band performances and theatrical productions, like the 1979 Fairfield High/Armijo High production of *Jesus Christ Superstar*.

The gym became more of a symbol of the school when the depiction of an Indian from the cover of the 1987 yearbook was painted on the outer wall along Texas Street in 1988. It stayed there until 2019, when it was painted over after the symbol/mascot was changed.

In October 2022, workers doing maintenance on the gym discovered asbestos. The venue was immediately shut down and reopened months later when repaired.

PAULA LINDSEY: I had Gary Vaughn at Armijo my freshman year in 1963–64. Johnny Walker, another freshman, was killed riding his bicycle on Highway 12 during Easter vacation. When we came back to school, Mr. Vaughn took the time to explain to a bunch of confused kids what happened. I can see him sitting on the corner of his desk—one foot on the floor and the other leg draped over the corner. He didn't play the macho card. He spoke from his heart and wasn't afraid to let the tears fall. That simple act helped us process Johnny's death.

BROWNLEE MEMORIAL FIELD

James Erskine Brownlee served as Armijo principal and teacher from 1921 to 1946. After retiring from being the head honcho on campus, he taught civics and biology for three more years. In addition to his administrative duties and teaching, Brownlee coached at Armijo before the school landed iconic coaches Carrol "Buck" Bailey and Ed Hopkins. He coached the very first football team at Armijo, in 1926.

When Brownlee passed away on July 4, 1955, almost immediately a local campaign was launched to name Armijo's football field in his honor.

TOP ROW, LEFT TO RIGHT: Primo Colla, Jack Chadbourne, Don Athey, Vernon Athey, Bill Brownlee, Dick Harris, George Tomasini, Ben Oliver. BOTTOM ROW: Ed Hopkins, Manuel Campos, Jack Hopkins, Vernon Duren, Bill Fernald, John Oliver, and Harry Chadbourne.

The 1935 Armijo football team at the 1955 dedication of Brownlee Memorial Field. *1962 Armijo High Yearbook.*

The main people behind it were former students Harry Chadbourne and Fairfield mayor Chris Santaella. Other local leaders who were on board included Manuel Campos, Ward Sheldon and Dan O. Root II.

The field's dedication ceremony took place on September 30, 1955, at halftime of Armijo's game against the Livermore Cowboys. The 2,500 spectators watched the game and dedication under brand-new field lights. A plaque, now mounted on a rock on the north end of the field, marked Brownlee's tenure as a principal and coach.

Led by quarterback Jon Anabo and halfback Bud Tonnesen, who scored both of Armijo's touchdowns, the Indians won the game, 13–7. Coach Ed Hopkins was carried off the field on the shoulders of his victorious squad.

The Third Armijo High School Building(s)

Between 1950 and 1960, the city of Fairfield's population exploded. According to census records, it swelled from 3,118 residents to 14,968—a 380 percent increase. The Union Avenue structure was not built to educate that many young people (approximately 550 students was the max), and by the mid-1950s, plans were being formulated to build a new educational plant.

The logical spot was down Washington Street, where the gym already sat. Preliminary architectural plans were submitted for the blocks-long new school in 1956, and a bond measure was passed. There were about sixteen houses on Washington Street where the new school would go, but the district bought them and converted them into classrooms.

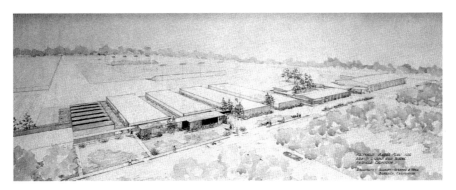

Architectural plans for the Washington Street Armijo campus. *Tim Farmer collection.*

While the new Armijo school was being built, students walked several blocks from the old school on Union Avenue to the house classrooms on Washington Street seven times a day. They had only eight minutes to reach their next class; members of the Cadet Corps would stop traffic on Texas Street for them.

By 1960, the new Armijo building—or rather, buildings—were completed, although the formal dedication wasn't held until April 27, 1961. Approximately 1,500 people were present at the dedication, which took place in the gym. The price tag for the new facility was $3.5 million (almost $36 million in 2023). The site included four wings of classrooms, a cafeteria, a music room, shop classes, a library and much more.

While the aesthetic appeal of the sprawling, fifty-acre school paled next to its predecessors, it has lasted longer. Now at sixty-plus years old, with modifications like a new administration building and library, it's still going strong.

Chapter 2

STUDENT LIFE THROUGH THE YEARS

Lest modern-day former students think that things were drastically different in the early days at Armijo, let the following from Julia La Shelle of the Class of 1918 dispel that notion:

> *I will never forget the first few months of this year in Armijo. We had heard everyone say that we were going to be hazed plenty and therefore I don't think anyone will blame us for being frightened. The first morning on our way to school, one of the rude seniors actually tripped some of us on those dangerous boards which are in front of the old building to serve the purpose of a walk. The senior then displayed her ignorance by laughing at us when we fell.*

The more things change, the more they stay the same.

Armijo Student Guides

There is a natural tension between students and administrators. The former often test the waters to see how much they can get away with, while the latter seek to rein them in. Over the years, Armijo's administration created rules to be followed—like those against hazing—that were codified into booklets and pamphlets given to new students and their parents.

Armijo High School

Comparing and contrasting the annual student guides from the past, some things remained constant or nearly constant: graduation requirements, tardiness rules and the like. Naturally, there are differences between today and, say, the 1967–68 guide. Back then, a pay phone was provided for students who needed to call home. Inside the cafeteria, a jukebox was available (adjusting the volume was prohibited).

The behavior rules for dances were strict and included requirements that students show their school identification card, couldn't leave unless they were leaving for good and had to request to bring a guest before noon on the day of the dance. In the 1968–69

Armijo student guides. *Tim Farmer collection.*

guide, a sentence was added to that section: "The guest must be a member of the opposite sex of the host and must meet the approval of the school authorities." That definitely would not fly in 2023.

When it came to the dress code, the 1967–68 guide included several very specific paragraphs. Boys were expected to dress presentably every day in jeans, slacks, shirts, sweaters or sweatshirts that were in good condition. Cutoff clothing was not acceptable. Beards were a no-no. Since this was the era when many young people started wearing their hair longer, the rule that students had to have an "average haircut" was detailed. Hair had to be short enough to stay out of the eyes, sideburns could be no longer than to mid-ear and skin had to be exposed above a normal shirt collar and around the ears. Yes, it was that specific.

Girls were expected to wear dresses and skirts that were not "too tight or short." Skirts could be no higher than three inches above the floor when girls were kneeling down. Many female students from that time vividly recall being told to kneel and having their skirts measured by Nurse Virginia Arvin. If it was too short, they were sent home to change.

By the 1972–73 school year, girls were finally allowed to wear full-length pants.

In the 1982–83 guide, the dress code was generalized and simplified to just one paragraph: "California State Law says: 'All pupils who go to school without proper attention having been given to personal cleanliness or neatness of dress may be sent home to be properly prepared for school.'"

32

In the 2022–23 Armijo Student Guide, clothing that could denote membership in a gang was specifically prohibited.

It is worth mentioning that while Armijo never had mandatory school uniforms, through the years many students have chosen, due to internal motivation or peer pressure, to adopt the clothing of the subset they most identified with. In 1989, for example, the yearbook describes the attire of rockers, preppies, surfers and other groups. In effect, students wore the "uniforms" of certain cliques in order to be accepted and fit in.

Diversity

The student body of Armijo from the mid- to late 1950s became increasingly more diverse racially. But Class of 1942 grad Jim DeTar contends that even before that, there was diversity at the school. "There were people from Suisun, from Tolenas, the elites from the valley, Hispanic kids, ones of

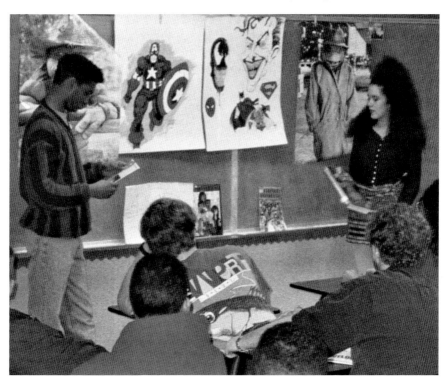

Tremaine Tucker (*left*) and Loretta Cabral give an oral report on how comic books are part of the mass media. *1993 Armijo High Yearbook.*

Portuguese extraction, Japanese extraction, Chinese extraction, kids from Oklahoma and yet everybody was always nice to everybody. We just kind of came together and treasured our years at Armijo."

While most past Armijo students could echo DeTar's sentiments based on their own experience, it is still disturbing to see racist "jokes" in early Armijo yearbooks. In addition to anti-Semetic jokes and even ones that use the n-word, misogyny was rampant in the pages of early school annuals. Sadly, the numerous examples are obvious and disturbing.

Controversies

The 1954 Strike

The Armijo student body made nationwide news when they staged an impromptu student strike on May 11, 1954, protesting the firing of social studies teacher John P. Marchak and vice-principal/mathematics teacher George Quetin.

Four months earlier, on February 8, a delegation of eighteen parents met with the school board and made allegations that Marchak had taught atheism and communism, given improper sex instruction to his students and disparaged the Catholic Church. Marchak denied the allegations.

Quetin had served as vice-principal and teacher at Armijo for eight years and felt that the Ethics Commission of the California Teachers Association (CTA) should be brought in to help with an investigation into the charges. After testimony was taken from seventy witnesses, the CTA issued a report on March 30 clearing Marchak of the charges and recommending that he be retained unless he did not have community support.

Ultimately, the board voted not to renew Marchak's contract and, at the request of Armijo principal Loren Wann, to terminate Quetin's as well. The decision to give Quetin the boot appeared to be based solely on the fact that he was the one who helped bring in the CTA.

The morning after the decision to oust the two popular instructors was announced, nearly all of the 450 students at Armijo clustered in groups on the lawn in front of the school instead of going to classes. They chanted, "We want Quetin! We want Marchak!" Principal Wann urged them to return to class, but they refused. They then filed into the Armijo Auditorium, and senior class president Michael Harper conducted the meeting and set the tone when he declared, "It's a bunch of crud, that's all it is!"

Board urged to quit after teacher firings

FAIRFIELD, Calif. (*P*) — A mass meeting of 450 persons called last night for the resignation of Armijo Union High School's five-man board of trustees in protest to the firing of two teachers.

The action followed an angry demonstration by the students against the firings. Almost the entire student body, some 450, went out on strike yesterday, demonstrating against the school authorities.

The school board Monday night failed to renew contracts of John P. Marchak, 31, social studies instructor since 1951, and George L. Quetin, vice principal and mathematics teacher.

The students held two meetings in the school auditorium, then paraded through town with banners denouncing Principal Loren A. Wann and the school board.

The board at first refused to say why the teachers had been dismissed but during Tuesday's demonstrations and arguments, Wann gave Quentin a list of charges against him. The charges mentioned a friction-producing attitude, aggressiveness, "moods" and "opinions."

Marchak was under fire last February when a group of parents charged that his teachings included detailed sex education of an immoral nature.

A California Teachers Association special commission investigated the charges and exonerated Marchak but suggested that he resign unless he had "clear evidence of overwhelming community support."

No such charges had been filed against Quetin but he said yesterday he was being fired because he had helped bring about the CTA investigation exonerating Marchak.

Teachers at Armijo Union High School have no tenure status and can be fired by the board without charges being preferred because the average daily attendance is under 500.

Vallejo newspaper article about the 1954 Armijo student strike. *Newspapers.com*.

The allegations had come from parents of students from the 1952 and 1953 classes. Some in the senior class pointed out how classroom remarks by Marchak could have been misinterpreted. One young woman said: "In order to stimulate thinking Marchak would say 'Okay, I am an atheist. Show me where I am wrong.' He obviously didn't mean he *was* an atheist, he just wanted us to start thinking."

As for communism, Marchak never advocated for it, according to another student, but taught the students what it was so that they could recognize it.

Marchak was the senior class advisor as well as a teacher and had five married girls and two married boys in his classes the previous year. He answered their questions about sex privately on request. One senior girl summed up the meeting to raucous applause when she declared, "We wouldn't be here if a bunch of old hags hadn't gotten on the phone and started to gossip!"

At the impromptu student assembly, Principal Wann was booed and Quetin was cheered. They went back and forth until about 11:00 a.m.; then

Wann suggested they reconvene at 1:30 p.m. The students could bring their parents, and the school board would be present. Instead of going back to class, however, the students staged a demonstration downtown with at least twenty-five cars emblazoned with banners supporting the fired teachers.

When they reconvened, Quetin demanded a written list of the charges against him. When finally the reasons were delivered at 2:45 p.m., they consisted of nine rather flimsy items, including: "Very often you draw conclusions without getting all the facts," "You definitely have moods" and "You choose the wrong times to express controversial opinions."

That evening, yet another meeting was called, and approximately five hundred parents attended and formed a twenty-two-member Citizens Committee for Armijo High. They passed a resolution calling for Quetin and Marchak to be reinstated and for the five members of the school board to resign. The school board members stuck by their guns and refused to relinquish their seats. They argued that teachers did not have tenure at Armijo and thus firing and hiring was up to the board.

Eventually, getting nowhere with the school board, the Citizens Committee sent a delegation to Sacramento to try to go over their heads but were told that local school boards were autonomous.

The story of the strike was picked up by United Press International and was in newspapers all over the United States. Locally, the *Solano Republican* printed a free special edition that was distributed to every home in Fairfield. It contained an interview with Marchak about the specific charges. After denying and clarifying what he had and had not said, Marchak was asked if he thought he had made an error in the way he conducted his classes. "Let me say this," Marchak said. "If I am guilty of anything, I am guilty of expecting these students to think and think things through and they are not quite ready for it. I am guilty of wanting them to think."

Quetin and Marchak were not reinstated.

An editorial in the *San Francisco Chronicle*, "The Fairfield Revolt," challenged a remark by Principal Wann that "schools can't afford to have controversies these days." After it praised the reaction by students and parents with the sentence "An American community has shown that it won't take accusations as the proof of guilt," it made an even more expansive point. "Controversy is a product of freedom of speech and thought and the only time you're free from controversy is when you're dead or under dictatorship. Frantic retreat from controversy forecloses rational processes, denies justice and enfeebles the vitality of freedom."

Student Life Through the Years

1950s and 1960s Bomb Threats

The reasons for teens calling in anonymous bomb threats to Armijo could range from malicious mischief to vengeance to boredom, but whatever the reason, there were many during the 1950s and '60s. In April 1956, Armijo principal John C. Lucas wrote an editorial for the *Armijo Scout* (school newspaper) thanking the students and staff for their resolve and the efficient way they exited the classrooms during a bomb hoax.

In September 1961, two calls were made in the space of two hours, causing the entire student body to be removed from classes while police searched for an explosive device. The students evidently took it in stride, and while they waited on Brownlee Field, the band continued to practice. Suspects were arrested later for falsely reporting a bomb threat; one received a county jail sentence and another was put on probation.

That did not deter hoaxers the following year, as anonymous callers brought out police to three different bomb threats before the end of October.

The 1959 Car Crackdown

In February 1959, a major brouhaha occurred at Armijo when the administration announced a set of regulations for students driving cars on campus. About two hundred of the one thousand students drove either their own cars or their parents' cars to school. What triggered the new regulations was an incident in which a student driving a pickup lost control of the vehicle, struck a freshman girl and dragged her twenty-five feet. Superintendent John C. Lucas said it was a miracle she was not killed and issued a bulletin with reforms to the campus driving rules.

Parents were asked to sign statements of permission for their youngsters to ride with others, and lists of "registered" passengers needed to be posted on the windows of automobiles. Students had to park in the school parking lot on Washington Street immediately on arrival at school. Vehicles were to remain there until the final bell in the afternoon unless the students had special permission to leave.

No student driver could permit any other student to drive their car. They were also not allowed to give rides to unregistered students. Some students threatened to have a sit-down strike, but it never materialized.

1988: The Banning of Spuds Mackenzie

The name Honey Tree Evil Eye means nothing to most people, but for folks of a certain age, the name Spuds Mackenzie does. Honey Tree Evil Eye was the actual (if rather odd) moniker of a female bull terrier that played "party animal" Spuds Mackenzie in a series of wildly popular Budweiser beer commercials in the late 1980s.

The ads came under sharp criticism for marketing beer to minors. While Anheuser-Busch, the makers of Budweiser, balked at that assertion, T-shirts bearing the party animal's likeness were all the rage on the Armijo campus in 1987 and 1988. The administration banned students from wearing shirts bearing the logo of Budweiser or any other company advertising alcohol or drugs and/or using profanity.

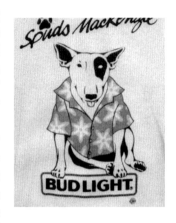

A vintage Spuds Mackenzie T-shirt, like the ones banned at Armijo in 1988. *Antoine Odell.*

Many students disobeyed the rule and started petitions, and an Armijo Spanish teacher, Mr. Carlson, wore a "Party's Over" T-shirt showing Spuds being run over by a Corona truck in defiance of the ban. (He removed it when told to do so.) The American Civil Liberties Union was rumored to be sniffing around to come to the students' aid, but it never got that far.

Many students were already peeved about a previous rule that banned hats and sunglasses in the classroom, and the Spuds ban was seen as a bridge too far. By the way, the first day of Spirit Week that year, when students dressed up on themed days leading up to homecoming, was Hats and Sunglasses Day.

The minor acts of rebellion continued into the following school year, as the 1989 *La Mezcla* featured a picture of the banned bull terrier with the caption "Still the Original Party Animal, no matter what the teachers say!"

In the 2022 Armijo Student Guide, such T-shirts are still prohibited.

GROWTH AND EXPANSION

Since its beginning, growth has been part of Armijo High School's story. The original students met in the upstairs of the Crystal School building until the first Armijo building was finished. When that space wasn't sufficient, the newer Union Avenue structure opened in 1915. When the exploding

Student Life Through the Years

An artist rendering of Fairfield Elementary in 1951, which became the Armijo Annex in 1972. *Fairfield Civic Center Library microfilm.*

Fairfield population made that structure obsolete, they moved the operation to Washington Street.

But it didn't end there. In 1964, just three years after the newest Armijo campus was formally dedicated, the original Fairfield high school welcomed a new rival to town, Fairfield High School. The opening of the new high school eased some of the overcrowding at Armijo, at least for a while.

In 1972, the Fairfield Elementary campus, located on Clay Street abutting Armijo, was annexed and became wings E through H.

Thirty years after the annexation, Rodriguez High School opened. In its inaugural year, approximately 250 Armijo students were siphoned off, along with some faculty, including baseball coach Dave Marshall, who became the new school's athletic director.

Lunch

The saying goes that breakfast is the most important meal of the day, but try telling that to a teacher attempting to keep hungry teens engaged in an afternoon class. The midday school meal has always been important in refueling young learners and serving as a time to decompress, socialize and cultivate friendships.

In addition to the hot meals served in the cafeteria, students in the 1950s and '60s had several choices within walking or short driving distance of campus to get sustenance and hang out with friends. They included the Sno-White (later the Sno-Man) right down the street on Union Avenue, the Chateau Café across Texas Street from the gym, Sid's Drive-In on the corner of Texas Street and Travis Boulevard, iconic Joe's Buffet, Dave's

Armijo High School

Foster's Old Fashion Freeze, where Yo Sushi is located in 2023, was a favorite Armijo student lunch spot. *1959 Armijo High Yearbook.*

Giant Hamburgers and many others. In 1959, Hi-Fi Drive-In on the corner of Gregory Street and West Texas offered a student lunch of a burger, fries and a drink for thirty-nine cents.

While hungry Armijo students brought in daily business, they also brought daily challenges. As the population increased, so did the problems.

In 1988, a petition that had been signed by eight hundred merchants and residents situated near the school was presented to the Fairfield-Suisun Unified School District asking that the campus be closed. It cited vandalism, theft, litter, drug deals and traffic accidents among other negative impacts as the rationale for their requested action. They argued that a closed campus could help with those tangible things as well as the intangible aspect of improving the school's tarnished image. It wasn't just Armijo High, by the way. Fairfield High was included as well.

A committee was formed, but it couldn't reach substantial unanimity on the issue. The main hurdle was that there were just too many students—nearly three thousand—to feed every day. The issue resurfaced in 1989, but again nothing changed. It wasn't until 2002, when Angelo Rodriguez High School opened, that Armijo High and Fairfield High became closed campuses.

Student Life Through the Years

Shady places to eat lunch on the campus. *2005 Armijo High Yearbook*.

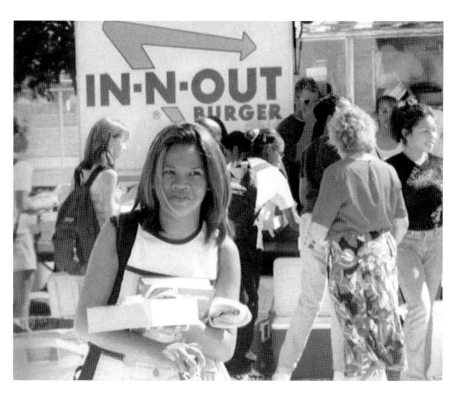

In-N-Out Burger on campus. *1998 Armijo High Yearbook*.

While students who had their lunchtime freedom suddenly snatched away naturally kvetched about it, the administration played the long game. In just a few years, the entire student body knew Armijo only as a closed campus.

It became such a non-issue that subsequent yearbooks routinely listed, in a rather playful manner, some of the most popular places on campus to eat lunch. They included the picnic tables near the Indian Outpost snack bar, the quad, the band room and other locations. Leadership advisor Mr. Burzynski's classroom was cited as a favorite in the 2011 *La Mezcla*.

When students cruising down to Taco Bell, A&W, McDonald's or Carl's Jr. was off the table, Armijo's administration had to get creative in making sure kids got fed. Instead of students leaving campus to patronize their favorite drive-thrus, the administration brought some of the outfits to the students. In-N-Out Burger sold Double Doubles and Animal Style Fries right there on campus.

Traditions

Spirit

School spirit is not easily definable, but in a general sense it is having the best interests of the school at heart and working for its good all the time.
—La Mezcla *1917*

The amorphous thing called school spirit binds faculty, students, parents and hopefully alumni together in a shared sense of belonging and pride about the school. It can be stoked by pep rallies, athletic events, participation in clubs and similar organizations, and it can ultimately become a basis for lifelong connection and friendship.

Over the years, many different methods to increase school spirit have permeated the student body. In the 1915 *La Mezcla* yearbook school spirit was reported to be at a very high pitch, partly due to the pride many felt about their brand-new school building.

Five years later, however, an editorial in *La Mezcla* called out students, athletes, teachers, parents and the general Fairfield public for their appalling lack of school spirit.

The most visible proponents of school spirit are, of course, cheerleaders. Back in the day, they were called yell leaders and were, more often than not, male. For example, the 1924 *La Mezcla* reported that yell leader D.C.

Student Life Through the Years

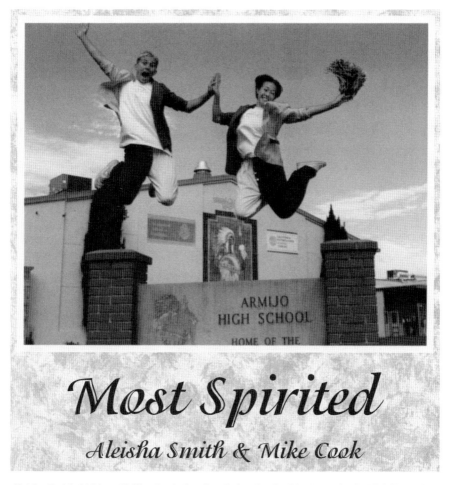

Aleisha Smith (*right*) and Mike Cook showing their school spirit. *2000 Armijo High Yearbook*.

White and assistant yell leader A.E. Needham "had perfected a snappy set of motions and kept things peppery at all Armijo gatherings."

Cheerleaders don't show up in the local historical record until the 1949 *La Mezcla*. They were augmented by pom-pom girls, drill team members and mascots.

Spirit week leading up to the homecoming football game would encourage students to come to school dressed according to different themes. Over the years, these included, but were not limited to, Tie Day, Punk Rock / New Wave Day, Twins Day, Little Kids Day, Bad Hair Day, Toga Day and Clash Day. Friday was traditionally Purple and Gold Day. An interesting phenomenon is that the actual clothing styles of one generation of students

Pom - Pom Girls

LEFT TO RIGHT: Phyliss Coulter, Marlene DeVera, Carolyn Creager, Lynn Wolff, Claire DeVaughn, Vicki Bird.

Late 1950s pom-pom girls with the Spirit Bell. *1959 Armijo High Yearbook.*

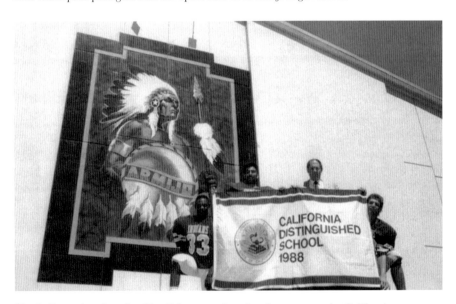

The Indian painted on the side of the gym when Armijo was named a California Distinguished School. *1988 Armijo High Yearbook.*

would become the caricatured costumes of subsequent ones—Hippie Day and Disco Day, for example.

School spirit at Armijo may have hit a peak in 1988, when it was named a California Distinguished School. Around that time, graduating seniors had been awarded over $1 million in scholarships and had four semifinalists in the National Merit Scholarship Program.

Armijo's application was reviewed by a state-level selection committee and was chosen as one of sixty-nine schools to be visited to validate the application. During that visit, the team talked with students and staff and looked at the Leadership Class, programs, policies and facilities. Armijo, the only school nominated in Solano County, was one of only eight schools to receive honors in both performance and improvement. Principal Leo Petty accepted the award at a reception in June. The 1988 yearbook proclaimed on the front cover that Armijo was "The Best in the West."

Homecoming

The November 25, 1911 football game between the University of Kansas and the University of Missouri is generally considered to be the first college football homecoming game ever played. The celebration included parades, parties and a pep rally that culminated in the gridiron contest.

In the mid-1950s, Armijo jocks and pranksters the Pizzarino Boys (see chapter 5) were known for high jinks like sneaking into the girls' locker room and waiting in line with mops on their heads to be initiated into the Girls' Athletic Society. But in 1957, they were instrumental in starting the homecoming celebration at Armijo.

Evidently, they envisioned a Homecoming Queen contest, in which they would auction off the first dance at a penny a vote to the highest bidder. Their motives for collecting the money were not exactly pure; eventually, administration "suggested" it become a project of the Block A Society and The Armijo Boosters. Along with the help of many others, the three-day event became a success and an established tradition that

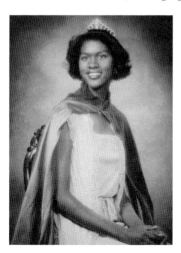

Michelle Dixon crowned as the Homecoming Queen. *1980 Armijo High Yearbook.*

continues to this day. In 1968, a basketball homecoming game and festivities were added as well.

In addition to parades, floats, a dance and the crowning of the homecoming court, skits were presented in a competition between classes. The 2002 homecoming skits had a Movie Night theme. Entries included Mary Poppins and the Oompa Loompas from *Willy Wonka and the Chocolate Factory*.

In 1974, Doug Woodard was the first male to be a candidate for Homecoming Queen or attendant. The yearbook stated: "He lost, but it marks a definite change from homecomings past and the consequences may be felt for years to come." In 2022, Armijo chose its first female Homecoming King.

Clubs and Organizations

On-campus clubs and organizations have benefited the intellectual development and social interactions of the student body for decades. Some of the earliest clubs at Armijo were a boys' glee club and girls' glee club, the Pig Club (which later morphed into the more appropriately named Future Farmers of America), Welfare Club (students interested in making the lives of the less fortunate better), Debating Club, Scholarship Society, Dramatics, Spanish Club and the Radio-Telegraphy Club.

The mural created by the Mexican-American Youth Organization. *1986 Armijo High Yearbook.*

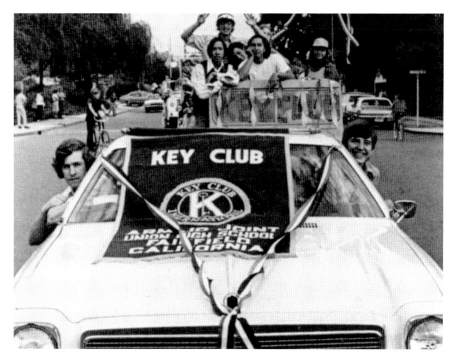

The Armijo Key Club in the Homecoming Parade. *1974 Armijo High Yearbook.*

Later clubs and organizations included the following: Distributive Education Clubs of America (DECA); Key Club, sponsored by the Kiwanis Club; Black Student Union; Mexican-American Youth Organization; Chess Club; Wargamers Club; Academic Decathlon; and many others.

The Cadet Corps was started by teacher Ivan Collier in 1956, and the Armijo Air Force Junior Reserve Officers Training Corps (AFJROTC) California Seventy-First (CA-071) Cadet Group was activated in September 1972.

More recent clubs and organizations include the Gay-Straight Alliance, K-Pop Kraze, Boxing Club, Board Game Club, Video Game Club, College and Career Club, Future Medical Professionals and Robotics Club.

Dances, Hops, Sadie Hawkins and Proms

Armijo Class of 1969 grad Johnny Colla of Huey Lewis and the News cowrote the no. 1 Billboard hit song "The Power of Love," as well as "Back in Time," both for the 1985 soundtrack to the blockbuster film *Back*

to the Future. There is no evidence, however, that Armijo had any other connection to the film.

Still, in the movie, the high school event where Marty McFly's parents, George and Lorraine, fall in love after their first kiss was The Enchantment under the Sea Dance and took place on November 12, 1955. On March 23, 1956, the Armijo Junior Prom theme was Underwater, and decorations consisted of long blue crepe-paper streamers that simulated ocean waves. At one end of the gym, a brown sunken galleon was erected, and just opposite was a huge fish head through which couples entered the gym. The band sat in a big golden chariot drawn by two giant seahorses. Was this a coincidence? You decide.

Homecoming dances, sock hops, Sadie Hawkins (where girls flipped the script and asked the guys out) and proms have been social hubs for Armijo students for decades. In 1958, seventeen-year-old Bobby Freeman had a no. 5 Billboard hit with his tune "Do You Want to Dance." He was scheduled to perform at the Armijo Junior Prom that year, but he bailed and accepted an offer to appear on *The Dick Clark Show*.

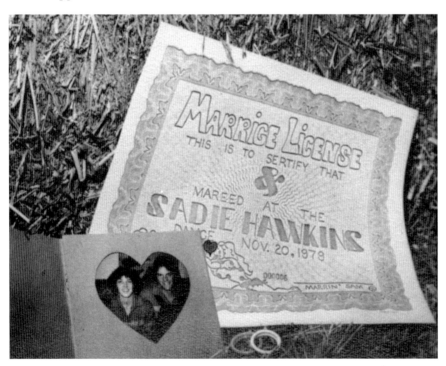

A "marrige license" for couples who got "mareed" at the Sadie Hawkins Dance. *1980 Armijo High Yearbook*.

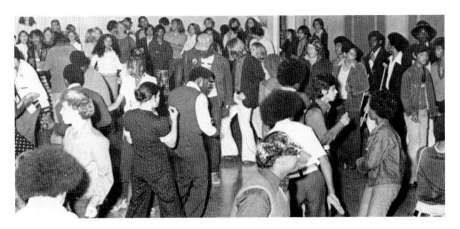

Armijo students gettin' their groove on at a dance in the gym. *1974 Armijo High Yearbook.*

A YouTube video of Freeman's performance exists (http://bit.ly/FreemanArmijo). Clark, interviewing actor Tony Randall, says that Freeman was "supposed to perform at the junior prom at Armico [sic] High School in Fairfield, California." Freeman did later perform at an Armijo rally on the back of a flatbed truck and then at a dance at Suisun City's M&M Skateway.

In February 1977, Armijo principal Gene Dillman canceled all dances except for the Junior and Senior Proms. The reasons for the drastic action were many and were listed in the school newspaper, the *Joint Union*. They included lagging attendance resulting in money being lost on the events, vandalism and students openly drinking, gambling, smoking pot and trying to force their way into the dances without paying. Dillman stressed that even the dances that were being allowed would be held on a probationary basis and take place between 4:00 p.m. and 7:00 p.m.

More recent dances held at Armijo are silent discos, in which music is broadcast via a radio transmitter with the signal picked up by wireless headphone receivers worn by the participants.

Armijo students shared memories of shakin' their groove things:

PATTI THOMING: In the '60s a few of us girls weren't asked to the Prom so we all went to the movies instead. We didn't wear our prom dresses, but that would have been cool!

CHUCK DAVIS: My prom story was "my girlfriend goes to the prom with someone else" or as it will forever be remembered, "Highway to Hell."

DONNA COVEY: In 1963, I was a freshman and while walking down the hall of A-Wing going to my next class, the word started to spread that President Kennedy had been shot. The annual Sadie Hawkins dance was planned for that night. The dance was canceled, and the student body was gathered into the gymnasium in the afternoon to collectively hear the tragic news of the death of our president.

Seniors Painting Washington Street / The Parking Lot / Behind A–D Wings

In the 1960s, after the school had moved from the Union Avenue campus, an annual tradition began. Close to graduation, seniors would paint personalized messages and pictures on Washington Street in front of the gym. Eventually, the spot for grads to express themselves was moved to the student parking lot. As of 2023, it is behind A–D wings.

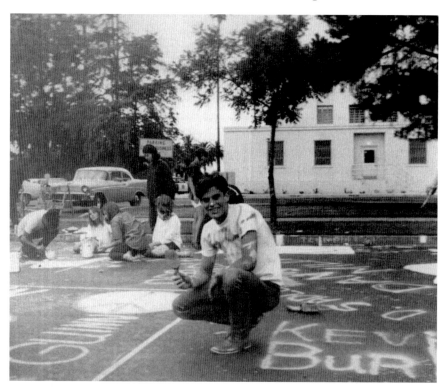

Greg Hart, Class of 1968, participating in the senior painting of Washington Street. *Donna Woods Ingram.*

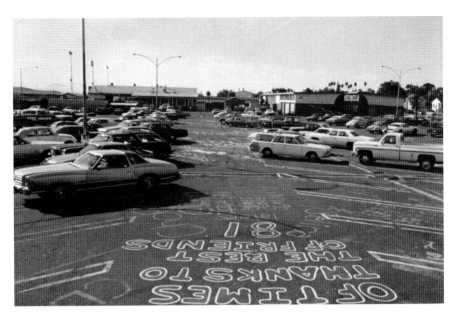

The Armijo student parking lot with painted messages from seniors. *1982 Armijo High Yearbook.*

Former grads looked back on the commencement creativity:

LINDA AMES: By the time I graduated, Washington Street was so crowned by repaving every year that we painted the parking lot. One of the very artistic guys of 1976 painted a large likeness of Peter Frampton.

TOM MCDOWELL: When I was a kid, one of the highlights of summer vacation was riding my bike over to Armijo to see what the seniors had painted the week before.

SAN NICOLAS GIOVANNI: My sister and friends from the Class of 1975 painted theirs on top of the band room. It stayed up there until they put a new roof on it. I still wonder how they got up there.

Graduation

So how old is Armijo High School? Well, it predates the quintessential graduation theme song "Pomp and Circumstance" by a decade. That regal 1901 instrumental march by British composer Sir Edward Elgar can

The Class of 1982 in front of the courthouse. *Armijo High class photo*.

transport graduates back to the transformative moment when they put a period (or exclamation point) on their high school journey.

The first graduation at Armijo occurred in 1893, and four students received their diplomas: Malwine Bronson, Grace Bronson, Jasper Finney and John Gregory. Jasper, better known as J.J. Finney, later went on to become principal of Crystal Grammar School in Suisun City.

The Class of 1915 had only sixteen members. Mina Lockie wrote in the *La Mezcla* yearbook: "We are now overflowing with excitement, preparing for commencement exercises where we will receive our diplomas. We will bid farewell to old Armijo and our future lives will be what we make them."

Others shared graduation memories:

JoAnn Hinkson Beebe: I got the "pleasure" of sitting between two boys that had flasks in their pockets under their gowns with plastic tubing running up their sleeves. They did manage to stay upright to receive their diplomas, but when it came time to exit, I had to push one by the back of his collar and pull one by his tie to get them off the field. I invented the original Pushmi-Pullyu.

Janet Cline Kohlwes: The day I graduated, my mother was in the hospital after having a kidney removed due to cancer. After the ceremony, a couple of friends and I went to the hospital. I donned my cap and gown and my friends hummed "Pomp and Circumstance" as I swept into the room, holding my diploma. My mother didn't cry—she was too zonked on pain meds—but the staff did. It was the only thing I could think to do that would include her in the day.

CHUCK DAVIS: The night before the last day of school in 1976, somebody climbed on the gym's roof, tied an industrial water hose to a quad picnic table and pulled it up to the apex of the roof. Then they painted "Chuck Davis" on each side of the roof just below where the table was perched.

The next day I was told I was not going to graduate for painting my name on the gym roof and putting the picnic table up there. I said, "What kind of fool would be stupid enough to paint his own name up there? Someone set me up!" After calls to my parents and my continued denial, I was allowed to graduate.

If the statute of limitations has expired, I have a confession to make. If not, I am still denying any connection.

Sober Grad Night

Postgraduation parties are not new. The Class of 1967, for example, had an all-night soiree at the Fairfield Bowl. Too often, though, the celebrations included alcohol and led to tragedy. It became a sad and almost inevitable

Class of 2022 seniors celebrating their graduation. *Fairfield-Suisun Unified School District.*

annual event that, around the time of graduation, local teens would be involved in fatal drunk-driving accidents.

In response to that, the first Armijo Sober Grad Night occurred on June 11 and 12, 1992. Nearly 75 percent of the graduating seniors attended, and there were five different themes: Paris, Hawaii, Hollywood, Monte Carlo and Rio de Janeiro.

The festivities included a casino, miniature golf, billiards, table tennis, a mime, carnival games and a tattoo artist. The grand prize was a 1986 Audi, given away at 6:00 a.m., when the party ended.

Chapter 3

TEACHERS AND FACULTY

*One looks back with appreciation to the brilliant teachers,
but with gratitude to those who touched our human feelings.
The curriculum is so much necessary raw material, but warmth is the vital
element for the growing plant and for the soul of the child.*
—Carl Jung

Rebecca Lum: Hard-Nosed Softie

Much-beloved Armijo High and Solano Community College mathematics instructor/coach Rebecca Lum, who passed away in 2020, was born, raised and went to school from kindergarten to college in San Francisco.

Lum's father emigrated from China to the Golden Gate city in the 1920s, and her mother was born there. Lum and her three siblings all had both Chinese and American names. Her Chinese name was Sook Wah. "My father owned a grocery store, and my mother worked at a sweatshop sewing for Levi Strauss and other companies," Lum said. "I worked there when I was seven years old. I stacked and folded Levi's jeans for seven cents a dozen. That was my candy money!"

Lum was not the top in her class at math, but she was very aggressive. She also channeled her competitiveness into sports like badminton, basketball, Ping-Pong and tennis. Chinatown had neighborhood playgrounds, and the children competed against one another for city championships, for which she earned several medals.

Teachers and Faculty

Ms. Rebecca Lum with Class of 1978 grad Belinda Silva-Attianese. *Belinda Silva-Attianese.*

When Lum launched her teaching career in 1956 in San Carlos, she faced obstacles. "I could teach there, but I couldn't live there because I wasn't white. People would have a vacancy sign in an apartment window, but when they saw me walking up, they would say they were full," Lum said. "The first place I found to live was a studio apartment in the back of a plumbing supply office."

When Lum came to Armijo two years later, however, what she found was the cultural gumbo of students from different backgrounds complementing one another. "We had people who lived in Country Club housing and people who lived in public housing," Lum said. "They all meshed and got along together. It was very diverse."

Lum points to the unselfishness of a former colleague for helping her get established at Armijo. "I have to commend and salute Conrad Shepherd, because he gave up his trigonometry class. Everything I have done is because he trusted me to teach that class, and that was in the 1960s. He was a man ahead of his time," Lum said.

Armijo students were at a mathematical disadvantage when they went to college, because Armijo did not offer calculus. When the policy changed, Lum taught the course and noticed a seismic shift. "Before we offered calculus, students' goals were to get into UC Davis or Cal Berkeley. But afterward, they went to Stanford, Yale, Harvard, West Point, the Air Force Academy, the Naval Academy and Cal Tech. It gave them an edge and confidence," Lum said.

Lum's small stature was belied by a huge no-nonsense attitude that served her well in both her life and career. Badminton and swimming participants knew that if they messed up, she was likely to call them out by referring to

them as a "hamburger." Lum thinks her toughness is maybe a bit overstated. "It's because my voice is so loud, but I'm really a softie."

Lum retired from Armijo in 1991 but continued teaching and coaching at Solano Community College until retiring for good just before her eighty-ninth birthday. Her Solano College job led to a different educational experience: teaching intermediate algebra to inmates at California State Prison Solano. "One of them told me if I had been his math teacher in ninth grade he wouldn't be in prison today," Lum said.

She encouraged them to continue their educational journeys when they were released, which reflected her life attitude of smashing through obstacles. "My philosophy is don't give up and believe in yourself. Like a salmon swimming upstream, all the odds were against me and I just wouldn't give up," Lum said. "When I was going to school and said I wanted to be a science teacher, all my counselors kept saying I'd never make it. Good thing I was hard of hearing."

MOLLY SHOCK: Ms. Lum was absolutely everything you wanted in a teacher. She knew her subjects so well. I had her for trigonometry, which I loved, and calculus, which I hated. She believed in you, she pushed you, she celebrated your achievements, but she also wanted you to become a complete person.

SHUGIE COBB: I'll never forget her telling us in the locker room to shave the grass under our arms! Loved Miss Lum!

GINA PITTMAN: She was my PE teacher from 1960 to 1964. She called me a "hamburger." It was her affectionate way of saying I was the least athletic person she had ever met. She had such patience with this "hamburger." I was the tallest one in our PE class, and it baffled her that I couldn't play basketball, not even dribble the ball.

KEVIN CHRISTIAN: If someone was messing around in class, all she had to do was make eye contact and say, "Please." That's all it took. They would stop whatever they were doing.

JONATHAN HOFLAND: Ms. Lum touched so many lives. She lived her life well. She was like the Mother Theresa of Armijo High School.

Alex Scherr: It's All About Respect

Alex Scherr taught at Armijo from 1965 to 1989. In his first year, he taught business English for juniors and seniors and college prep English for sophomores. Scherr developed a rapport with students by reinforcing his primary rule in the classroom: Be civil to others at all times. He also fit right in with his colleagues.

"We had a great faculty the first few years. We would have weekly gatherings with the staff in the gym and have some fun. We had progressive dinners, played basketball, had get-togethers in different homes—it was a very congenial group," Scherr said. "Of course, as the faculty got larger those kinds of things fell by the wayside, but nevertheless, a very congenial group. I can say with great pleasure we were very interested in the education of our students."

While there were some bad disciplinary incidents over the years, one especially proud moment at Armijo sticks out in Scherr's memory.

> *We had the special education kids from the county program come for the Special Olympics. At first some of the students were making fun of them, but in the afternoon the Armijo Super Band, led by Mr. Lindsey, played the Olympics theme when all the athletes came out onto the field and all the students were out there cheering and applauding those special kids. No one was making fun of them. They were treating them with great respect. That's the kind of thing I saw take place at Armijo that I really loved to see.*

Armijo English teacher Alex Scherr (*right*) and Judy Scherr at the Armijo High School Hall of Fame in 2015. *Yumi Wilson Photography*.

After being widowed in 1982, Scherr married his current wife, Judy, the following year. After retiring (he refers to his retirement party as a "graduation party"), he substitute taught for seven years.

In 1996, Scherr and his wife relocated to Nevada. The first four years there, he worked as a janitor at a brand-new Safeway store. "I enjoyed the people I was working with, and that broom or mop never complained," he said.

Nurse Virginia Arvin: Treatments with TLC

Virginia Marshall was a Vacaville native who graduated from Vacaville High in 1940. Five years later, she married Burke Arvin and in 1947 became the school nurse at her alma mater. She worked there until 1952, when she came to Armijo. She was a fixture at Armijo until 1986 and also worked at Fairfield High. Nurse Arvin died in June 1996, and generations of students remember her.

LINDA PACE: From 1964 to 1968, Mrs. Arvin would call you into her office if she thought your skirt was too short. You had to get on your knees, and your skirt had to touch the ground. If it didn't, you had to go home and change.

DALE PONCY: In 1974, I almost cut my finger off in woodshop. Mrs. Arvin had a brand-new Chevy truck. I was concerned about bleeding all over her seats, but she was only worried about getting me to the hospital. Always a nurse first.

TONY HORST: Nurse Arvin should have a plaque or, better yet, a bronze statue erected in her image and likeness placed right outside the main office at Armijo. She's the reason many kids became something more than what they thought they were going to settle for in life. The statue alone would probably make the kids these days think twice about being no-goodniks and turn out to be better adults. Take it from someone who knows all too well. She was a great mentor who cared, even if she was a little rough around the edges.

NANCIANN GREGG: We moved here from Ohio and as a freshman I held onto the way we dressed back there: socks pulled up to my knees and

TEACHERS AND FACULTY

Dedication

The Yearbook staff dedicates this 1959 La Mezcla to Mrs. Virginia Arvin.

As school nurse she is never too busy to take care of our aches and pains; as attendance officer her little Ford travels untold miles tracking down missing students; as a friend and trusted confident she is always willing to listen to our personal problems.

She sometimes scares the Freshmen, but soon becomes "Ma" to all of us. "Ma" Arvin's office is one of the most popular meeting places in the

The dedication of the 1959 yearbook to longtime school nurse Virginia Arvin. *1959 Armijo High Yearbook.*

unpolished shoes. Mrs. Arvin called me into the office and said, "If you ever expect to fit in you'll need to roll your socks down and polish those shoes." My friend Emma Jo Ramirez was in the office at the time and started laughing, and we still comment on that today and laugh. Nurse Arvin was also the truant officer at Armijo in the '50s. If she thought you weren't sick enough to be at home, she got in her little green coupe and came and got you.

JAIME SMITH-MEYER: In 1986, in gymnastics, I broke my arm, and it was a compound fracture—my arm was shaped like a Z. Nurse Arvin was the most amazing, calm person. Exactly what a hysterical sixteen-year-old needed at the time!

NELDA MUNDY: A LEGACY OF LEARNING AND LOVE

According to her daughter, Tracy Beasley Hilts, Armijo teacher of business and business law Nelda Mundy would be the first to praise and affirm students doing something right. But she was also not to be trifled with. "One thing about my mom, she was just real. For example, she would tell young men, 'Pull up your pants because they don't pay me enough to look at the crack of your ass!' She had sweaters in her classroom, so if young ladies came in and she was not impressed with what they were wearing, she would ask them if they woke up late and didn't finish getting dressed and hand them a sweater to put on." Hilts continued, "She was about teaching people to respect themselves and to respect other people."

Evidently, parents were also not allowed to get away with any shenanigans. "There was a young woman who had clearly plagiarized an assignment, and her father came in my mom's classroom demanding that she be given credit for it. My mom refused. He got belligerent, and my mom told him to leave," Hilts said. "He didn't and said a few choice words, and my mom pounded her fist on the desk so hard she broke her wrist and screamed, 'I said get out of my classroom!' He left."

Nelda Mundy was born and raised in Texas, and she picked cotton there growing up. She was the first in her family to graduate college. Her grandmother, who was the first of her ancestors to be born free, died in the 1970s at over one hundred years old after seeing her grandchildren graduate from college.

A chalk drawing of Nelda Mundy made by an inmate whom she helped achieve a GED in the 1970s. *Tracey Beasley Hilts.*

Mundy wanted people to experience the benefits of education. Before coming to California, she lived in Minnesota and volunteered at Stillwater State Prison. There she tutored inmates so they could get their GEDs. One appreciative and artistic inmate she helped in the early 1970s created a chalk portrait of his tutor, which Hilts still has. "One of the things she was most proud of was helping about a dozen students get into Jarvis Christian College, her alma mater, with scholarships," Hilts said. "They were kids who would not have had an opportunity to do so, and it was one of the greatest things she ever did."

In 1984, Nelda married Solano County deputy Ken Mundy. Their union was all too brief, as Ken Mundy died about four years later of cancer. "They were an amazing couple. Kenny would leave an encouraging note on her desk or car. They were a good representation of what finding love later in life could be," Hilts said.

That Nelda Mundy would herself be stricken with cancer was tragic enough, but it was exacerbated by the discovery that her complaints of something being wrong healthwise were repeatedly dismissed by her doctor as being all in her head. In fact, in her file he had labeled her a "Demerol seeker." By the time the cancer was discovered and properly diagnosed—eighteen months later—it was too late. "She suffered and didn't have to. But my mom was not hateful. She wanted the doctor to know that she forgave him, but to make sure that he would listen to his patients and not dismiss them ever again," Hilts said.

Six months after her diagnosis, Nelda Mundy died on December 30, 1996. One positive that came out of it is that after Tracy Beasley Hilts went through hospice with her mother, she became a hospice chaplain for seventeen years.

At Nelda Mundy's memorial service, guests were invited to write a memory down about her on index cards. Hilts has the cards—about five hundred of them. "Parents wrote notes thanking her for helping them reconnect with their children. Others wrote thanking her for the influence she had in their child's life," Hilts said. "One lady met my mom because she had left her purse on top

of her car and my mom found it, tracked the woman down and they became friends. She was that kind of person. She made you feel connected."

Nelda Mundy was one of several notable locals on a list of potential names for a new elementary school being planned in Fairfield. Her name was eventually chosen. It opened in 1998. "I'm grateful that God gave me the mom that I had and for the lives that she touched. I'm really proud of her as an educator, but she was just a good woman," Hilts said. "When I went to the dedication of her school, a young man came up to me after the ceremony. He was in tears and he said, 'I'm a teacher because your mom was my teacher and now I'm grateful to be teaching at the school named after her.'"

Virginia Scardigli: A Lifetime of Service

More than a few Armijo students from the late 1950s and 1960s chose their English teacher Virginia Scardigli as one of their favorites. "Loving" and "kind" are among the adjectives used to describe their white-haired instructor. Class of 1964 grad Donna Kilpatrick Stockebrand credits Scardigli with introducing her to poet Lawrence Ferlinghetti, who cofounded iconic San Francisco bookstore City Lights in 1953.

What many students and faculty did not know until after Virginia Scardigli's death in 2007 was the full scope of her incredible life before she decided, at age forty-two, to become an English teacher. According to her obituary, in 1933, Virginia Cardin graduated from UC Berkeley with a degree in anthropology, moved to Pacific Grove, married Italian sculptor Remo Scardigli and became part of a famed art and literary crowd that included John Steinbeck and Ed Ricketts.

During World War II, she moved to San Francisco, working for the Office of War Information, where, as part of her duties, she relayed information to the world from the first United Nations conference. Later on during the war, she assisted in the relocation of many Japanese students from internment camps into colleges. After Scardigli retired from teaching, she traveled the world and volunteered many

Virginia Scardigli, Armijo English teacher, who led a colorful life before becoming a teacher. *1962 Armijo High Yearbook.*

thousands of hours recording books for the blind and dyslexic and speaking at conferences about her Cannery Row experiences in the 1930s.

Several photocopies of original correspondence between her esteemed literary colleagues are now housed at the Center for Steinbeck Studies at San Jose State University.

Darrel Anderson: A Different Drum

An unspeakable tragedy, in part, is what drove English instructor Darrell Anderson to the West Coast and eventually to Armijo High. "In the spring of 1958, I taught English and was a speech coach at a school in a small town in Nebraska, and there was a girl who flirted with both the valedictorian and the mayor's son. The valedictorian and the girl were walking down the street holding hands, and the mayor's son shot them both dead with a shotgun," Anderson said. "He then put the gun in his mouth and shot himself, but he didn't die. I couldn't believe it. That was my first year of teaching."

Anderson moved to central California to escape both the horrible memories and what he described as the "limited attitudes" he encountered in Nebraska. He taught in Hanford before starting at Armijo in 1961. "In those days, everyone wore suits and ties to school, and you were expected to perform like a professor," Anderson said. "It was rather tight for me because I am kind of a loose guy."

Anderson conformed to the traditional teaching style, but when he became department head, he began to implement changes. "We thought we would make it more interesting for kids, so we split up classes into English electives that could meet different requirements," Anderson said. "We had tons of classes kids could take, including Advanced Composition and Social Protest Literature. They were very successful, and just going to class was exciting."

Anderson did not make students take tests but instead had them write papers. "Kids knew if they took my class they would have to buckle down and learn how to write because that's what I believed in," Anderson said. "They got graded on how well they wrote. That always seemed like the fairest way to do it. In that sense, I was pretty tough. They had to realize that reading and writing is the key to English."

Looking back over his thirty-two-year teaching career, Anderson is most proud of a system he helped develop called The Block. "We took the best group of students out of the seniors, about thirty-five kids, and the best of

the juniors, about the same number, and they took four classes in English at each level, four classes of math at each level, four classes of history at each level and four classes of science at each level," Anderson said.

"Dee Brown, George Aldredge, Becky Lum and I taught those classes. It was so incredible. Some of the kids in my classes were writing what you would expect from a college senior who was an English major."

When Anderson looked back on his career, what stood out was what drew him to teaching in the first place: a love of people. "I think kids are very sensitive to who likes them and who doesn't. If you genuinely like someone, they know it, and if you don't, they know that too," Anderson said. "There are a lot of teachers that just don't care about kids. I've always believed there is an art to teaching, and the key is to be empathetic towards people."

Principal Rae Lanpheir, aka "Big Daddy Rae"

Rae Lanpheir first encountered Armijo as a teenager—not as a student, but as a rival. He grew up in Napa and graduated from Napa High in 1965. "We played football and wrestled against Armijo. Napa was a little tiny town, and back then it was just a two-year school and Armijo was a four-year school and was big and scary," Lanpheir said. "Armijo was also very diverse, and Napa was very white. I grew up in Rancho Del Mar, which is now called American Canyon, but most of my friends lived in Vallejo."

Lanpheir's educational career began as a teacher at Sem Yeto High School in 1970, which lead to a job coaching football, wrestling and track at Fairfield High School. It also led to an amusing encounter at Armijo.

> *When I was at Fairfield High, I needed to borrow a wheel puller from Cal Baptiste at Armijo, who was the auto shop teacher. I called him and he said sure so I went there and as I was walking onto the campus some guy stopped me and said, "Where do you think you're going?" I told him why I was there and what I was going to do, and he said, "No, you're not." I said, "I'm a teacher," and he said, "Yeah, and I'm Mickey Mouse! Get your ass off my campus!" It was Gene Dillman, the Armijo principal. I went back and told my principal at Fairfield, and he said I needed to do two things. First, I needed to go to the District Office on Delaware Street and get a District ID, and second, I needed to grow a beard, because my baby face was just not working.*

In addition to coaching multiple sports at Fairfield High, Lanpheir also taught careers, psychology and sociology. He became dean of instruction in 1974 and at the time was the youngest administrator in California. In 1976, he moved across town to Armijo as assistant principal for four years. After that, he was promoted to principal at Mary Bird High School, where he stayed for twelve years and then came back to Armijo as principal from 1992 to 2002. "Being the principal at Armijo was like coming home. There was just something about Armijo and my personality and the personality of the community that just jelled," Lanpheir said. "By the time I became a principal at Armijo, I had the children of the students I had first taught there. When I retired, I had their grandchildren. It was a storybook romance for me."

Lanpheir felt it was very important for the school to be connected to its historic past, and he dug through the vault in the main office that had all the old yearbooks and other artifacts of bygone school sessions. He found six wooden blocks with letters on them that spelled out "A-R-M-I-J-O" that he remembered cheerleaders standing on when he was at Napa High. He took them home and restored them to their past glory.

Lanpheir also honored notable faculty members. Al Maddelena spent his entire career at Armijo and reinvented the industrial arts department twice. Lanpheir got permission from the district to have a plaque made that renamed it in Maddelena's honor. With the help of basketball coach Jay Dahl, they also got the floor in the gym named the Ed Hopkins Court and the little gym named after longtime wrestling coach Ron Cortese.

When Lanpheir first became principal, the school had thirteen identifiable gangs. His staff worked with parents and the students in meetings and town halls. In one year, there was a 54 percent drop in violent behavior. Those thirteen gangs declared Armijo a sanctuary, and there were no more gang fights. "It was something we did together. I wasn't afraid to say I was wrong or give people credit for what they did." Lanpheir said. "My job was to be the best cheerleader I could be for the school and community and to support my teachers and students and give them reasons to want to do better."

Every morning from 8:00 a.m. to 9:00 a.m., Lanpheir took no appointments and greeted every student. His assistant principals were required to spend an hour every day walking the campus. He once told some students that while they were at school he was responsible for their safety—he was, in effect, their dad. His term-of-endearment nickname "Big Daddy Rae" was born.

Lanpheir had a knack for making special moments happen. "One of the most precious moments of my life happened when I was at Armijo. A

Principal "Big Daddy" Rae Lanpheir being inducted into the Armijo High School Hall of Fame in 2015. *Yumi Wilson Photography.*

Japanese American student named Amy Uchimoto Naito, who had attended Armijo back in the 1940s, was taken to an internment camp a few days before graduation. Her diploma was mailed to her later, but she never received her academic awards," Lanpheir said.

> *When I went through the district archives, I discovered that not only did she have a scholarship, she was also the valedictorian of her class. In 1994, I invited her to graduate with that class. Her whole family came, Meyer's Jewelers gave her a watch, the superintendent gave her all her awards, we gave her a 1942 yearbook which she had never received, and Amy gave a speech. I get emotional thinking about it now. Amy was able to show her ninety-eight-year-old mother her awards. When Amy died, her children asked me to speak at her funeral.*

Brad Burzynski: Student, Teacher, Administrator

After Armijo Class of 2000's Brad Burzynski graduated from Saint Mary's College, he found himself back teaching at his alma mater. That hadn't really been his chosen career path. In August 2004, he met with Principal Rick Vaccaro, who said Burzynski could oversee the Leadership program and run the yearbook staff while he enrolled in teacher-credential courses. Burzynski, fresh out of college and essentially offered a full-time job with medical benefits, decided to try it out for a year.

"I was never more scared of anything in my life, but I also never loved anything so much," Burzynski said. "It was a wonderful experience right from the get-go. It's actually pretty common now that teachers get signed and then go through all their credentialing work while they perform the job they're in, but it wasn't at that time."

Both the leadership and the yearbook assignments had been dropped by his predecessors with no real blueprint for how to proceed, but Burzynski had been in Leadership during his four years at Armijo, so he was not totally lost. Networking with Fairfield High School's Clyde Carpino as well as others at the California Association of Directors of Activities (CADA) added even more skills to his toolkit. "It shifted my mindset from not just doing activities like powder puff or homecoming, but asking how we could provide service to others," Burzynski said. "How do we get kids to explore who they want to be beyond the walls of the school? So we developed mentorships and also a great relationship with our special education students."

Burzynski oversaw the yearbook production for a decade and was the student activities director for fifteen years. He already had one foot in administration for years, and after serving as assistant principal at Armijo under Sheila Smith, he moved to the Fairfield Suisun Unified School District office as the administrator on special assignment, extracurricular & co-curricular activities. While he relishes his role now, his time as activities director at Armijo holds a special place in his heart. "We had a Special Ed student at Armijo, and what I loved about him was that he played the bagpipes—and played them well. He would lead the spirit marches and he was the homecoming king one year," Burzynski said "We tried to create as many memories for students as possible."

Sheila Smith:
Steering the Ship Through a Pandemic

The effects of the COVID-19 pandemic that exploded in March 2020 were unprecedented in Armijo history. Or were they? The following editorial from a student is from the 1919 *La Mezcla* yearbook.

> *The one great hindrance was the Spanish Influenza, which called around at a very inopportune moment, breaking into our well-organized school regime, setting us back in our school work and causing our athletics, especially basketball, to almost completely go out of existence. During our first enforced vacation which lasted for seven weeks, we did absolutely nothing along the lines of school work, but lay idle around home or else put on one of those suffocating flu masks and assisted the Red Cross in their great activity in combating the dread disease.*

Armijo evidently opened up only to get shut down again, the second time for two weeks. Students' lessons were assigned to them in advance, and everything had to be handed in within a certain date. "I never imagined students would be overcome with pleasure at seeing school open, but there was never a happier crowd than is when we could recite to a teacher instead of outlining pages of material."

A century later, Principal Sheila Smith was at the helm at Armijo and had to help the school, students, staff and parents navigate the scary and uncertain waters of COVID-19. "Distance learning forced us to finally stop thinking of school with the traditional nineteenth-century structures in mind. Closing the physical campus focused our staff's flexibility and willingness to adapt on the fly," Smith said. "From Friday, March 13th at 3 pm to Monday, March 16th at 8 am, we began educating our students in an entirely different format. The administrators all worked on-site. It was lonely."

One of the things the new format highlighted was the inequity of resources in Armijo families. Not everyone had the means to provide the internet support that students need to access the curriculum and instruction. Also, for some

Sheila Smith, Armijo's first female principal, who guided the school through the ravages of COVID-19. *Armijo Alumni Association.*

kids, not coming to school meant not having access to food. Smith gave kudos to the school district for providing resources to ensure that students were fed and could access the internet.

Graduation for the Class of 2020 featured the usual elements: the Pledge of Allegiance, the national anthem, speeches by standout students, remarks from the principal and the procession of graduates. But it was a first in Armijo history, as it was not live, but a premade video on YouTube. Principal Smith offered these thoughts:

> *Class of 2020, I care about you and your well-being and because I care about you, I want you to face your future with an inner strength that helps you navigate whatever the world tosses your way. I am so sorry you didn't experience your senior prom or the other traditional events. I especially regret that you won't experience that bittersweet moment on the last day of school when seniors look across the empty campus and realize this part of the journey really is over. My advice for you is to live in the present, dream big, plan your future and be a positive force. I believe you are the people who must make our uneasy world better. We are counting on you.*

Charleston Brown: Lasting Connections

Former Armijo principal Charleston Brown set two records. He was the first African American to be principal, and he had the shortest term, only one year. The reason for his brief tenure was family. Brown and his wife live in Vacaville and chose to make spending as much time with their four children a priority. So Brown left Armijo and became the principal of Vacaville's Will C. Wood High School.

"Most times we pick work over family. My father wasn't around when I was growing up, and now I have a mile commute and my kid's daycare is down the street from where I work," Brown said. "It was not an easy decision to leave. My first week at Will C. Wood, I got messages and thought they were from parents. They were from Armijo students all asking me to come back because they missed me. They went out of their way to leave a voicemail, and kids don't do that in today's world."

In his brief time at Armijo, Brown made lasting connections with parents, staff and students. "Every morning I was outside thirty minutes early waving to parents and fist-bumping kids as they made their way onto the campus. During passing periods, I was outside. There's too many kids to know

Armijo principal Charleston Brown speaking at the Class of 2022's commencement celebration. *Fairfield-Suisun Unified School District.*

everyone by name, but I made a habit of complimenting everything that I saw," Brown said. "I had a desk on wheels that was 'Mr. Brown's Office.' I would take it down the hallways, take it to the quad, and I would do my work so the kids could see that I wasn't hiding in the office. I was committed to making sure our school would be safe and I would be visible."

Brown had been a high school counselor for five years before becoming a principal, and he prioritized respecting individuals where they were. "Once kids know that you care and you love them, then when you have to hold them accountable, it's not a personal issue," Brown said.

He was very aware of what it meant to the student body to be the first African American principal of the school. He also felt that undefinable but real grounding that Armijo possesses. "I think it meant a lot to the kids and community. Not only just the Black kids, but Latino, Persian and others as well. That meant a lot as far from the inner city as we are," Brown said. "There is a strong sense of community there among the students as well as a rich history among the committed staff. There are several teachers that graduated from the school whose kids graduated from there too. They are deeply rooted, and that says a lot about a campus. There is a strong sense of something manifesting in the air that gets filtered into greatness. When you walk onto that campus, it feels right."

Chapter 4

STUDENT STORIES

There are advantages to being elected President. The day after I was elected, I had my high school grades classified Top Secret.
—Ronald Reagan

To be clear, this chapter is not a focus on just the best and brightest who graced the hallowed halls of Armijo. It is an overview of *some* of the interesting stories about students that the school produced. To be sure, there are some famous alumni whose stories I cannot gloss over. But I covered them extensively in my first book, *Growing Up in Fairfield, California*, and I refer readers there for more details.

REFLECTIONS ON PAT MORITA BY HIS DAUGHTER ALY MORITA

Armijo High School Class of 1949 grad Noriyuki "Pat" Morita achieved fame first as a standup comedian and then as a television and movie actor. On the silver screen, he appeared in the movie adaptation of *Thoroughly Modern Millie*. On the small screen, he had bit roles in hit shows like *M*A*S*H*, *The Odd Couple*, *Columbo*, *Kung Fu*, *Sanford and Son* and others.

The acting role that first gained traction with the viewing public for Morita was as Arnold Takahashi, the namesake drive-in restaurant owner with an explosive laugh on the TV show *Happy Days*. In 1976, Morita starred

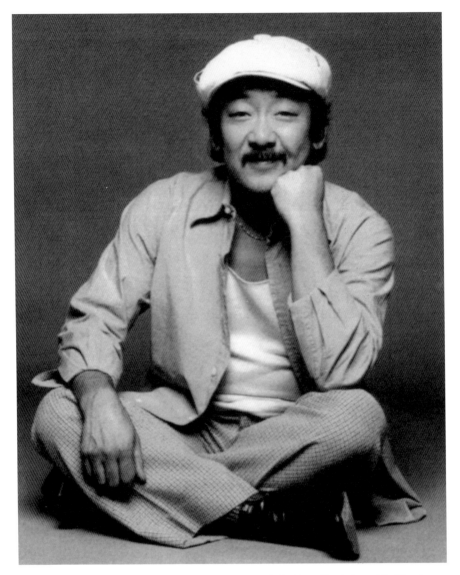

Class of 1949 grad Nori "Pat" Morita at the time of his short-lived show *Mr. T and Tina*. *Public domain*.

in the first U.S. sitcom to feature a predominantly Asian American cast, the *Welcome Back, Kotter* spin-off *Mr. T and Tina*. It was short-lived, but he also later starred in a quirky cop drama called *Ohara*.

Morita's most memorable role, for which he earned an Academy Award nomination, was martial arts sensei Mr. Miyagi in the 1984 motion picture *The

Karate Kid and its three sequels. Although Morita died in 2005, the legacy of that landmark role lives on in the current popular Netflix sequel series *Cobra Kai*.

In 2019, one of Pat Morita's daughters and talented writer, Aly Morita, came across a 2012 column I wrote about her father and contacted me by email. Plans for us to meet back then fell through, and then the pandemic happened. But in 2022, I was able to interview her by telephone. Aly gave me some firsthand insights about her father, and I was able to give her a copy of the 1949 Armijo High School *La Mezcla* yearbook.

Q: What were some of the peaks and valleys of your father's early acting career?
A: I was probably five or six years old when my father was on *Happy Days*. I have strong memories of that period. It played a huge role in his career and our lives. That was probably his first taste of fame so to speak as people recognized him as Arnold. He left *Happy Days* to do *Mr. T and Tina*. It didn't succeed I think for a myriad of reasons, including that the timing wasn't right and I don't think mainstream America was ready for a sitcom starring an Asian American. But that was an exciting and scary time. The *Happy Days* cast and crew were a close-knit group, as it was a long-running show, and over the years my dad ended up going back to the show.
Q: What was he like as a dad?
A: He was very hands-on. I had a bookcase that was in my room my entire childhood that he built with his own hands. I remember when I was in first grade he directed this play called *Really Rosie* [a musical with a book and lyrics by *Where the Wild Things Are* author Maurice Sendak and music by singer-songwriter Carole King]. It was a full-on production—singing, dancing, costumes, he even brought in a choreographer—the whole thing. He was very involved with me and my sister's lives as best as he could, working as much as he did. He was a great daddy. My childhood was really sweet. It wasn't until I was a teenager and *The Karate Kid* happened that I realized I would have to share him with the rest of the world.
Q: I have read online where you talked about how *The Karate Kid* was awesome…and it also wasn't so awesome at the same time.
A: There are a lot of perks that come with celebrity, and certainly my dad and my family enjoyed those benefits: flying on the Concorde, getting great concert tickets, staying in five-star hotels, flying all over the world—that was the glamorous part of it. On the other hand, it was tough for my dad to navigate. It's a very damaging world that famous people exist in. It's a lonely place. I think it took its toll on him after many years.

Q: Back in 2010, when the remake of *The Karate Kid* came out, you were against it. Why?

A: Mostly it stems from the fact that there were so few meaty, three-dimensional, interesting roles for Asian Americans. My dad was lucky enough to land one of those roles, and he ran with it. He put 150 percent of himself into that role. It was the one thing that he had done in his career that stood out. It was hard to see billboards going up and the press about the new *Karate Kid* when it hadn't been five years since my dad had passed. Basically Will Smith bought the franchise and gave it to his kid to start his career. It felt like Will Smith and that whole machine was taking that away from my father. It also angered me that twenty-five years after the original film came out the only movie Hollywood could make starring an Asian character was *Karate Kid*. Now, today there are more opportunities and representation of Asians and Asian Americans in film like *Crazy Rich Asians*, but in 2010, I was baffled and angry. I think I have since come to terms with it. I have seen the remake, and Jaden Smith gave a great performance, so I don't want to knock him. Thankfully, things have changed since then in terms of Asian American representation. But I still hope that more stories will be told.

Q: The hit Netflix series *Cobra Kai* has created a whole new generation of fans of *The Karate Kid* saga; what are your feelings about it?

A: I've watched it and I had been in touch with Ralph [Macchio] when it was on YouTube before going on Netflix. I think they've done a great job and it helped jump-start Ralph's career, which he so deserves, as well as those of Billy Zabda and Martin Kove. I think it's fantastic for them and I think they are having a lot of fun with it. I think my dad would be very happy for them.

They have said they want to do more about the Miyagi storyline, but I have yet to hear from them about how they are going to do it. There were discussions about having a Miyagi prequel back when my dad was involved in the movies, but nothing has been done. It would be nice if Miyagi's story was incorporated more into the narrative, as he was 50 percent of the story.

Q. A lot of people don't even refer to your father by his name but as his most famous character.

A: Yeah, he didn't really know karate or talk like that. He was an actor doing his job [*laughs*]. He speaks perfect English and is quite articulate. He was a very larger-than-life, dynamic guy. That surprised a lot of people.

Q: What is something that most people don't know about your dad?

Student Stories

The inside back cover of the 1949 *La Mezcla* drawn by Nori "Pat" Morita. *1949 Armijo High Yearbook.*

A: He wanted to be a doctor after he graduated from high school. He received a scholarship to Berkeley and wanted to begin pre-med. I think that came from having grown up in an infirmary as a child and being attended to there. I mean, the doctors and nurses and other kids there were his family. But his parents told him they needed him at the restaurant they owned in Sacramento, so he had to forego his dream of becoming a doctor. He was so angry that while he worked at the restaurant he spent a lot of time in the pool halls. His mom didn't like him doing that, but his dad was also a great pool player.

Q: Your dad was pretty artistic, right? The inside back cover of the 1949 yearbook features a picture he drew of a 49er mining for gold.

A: He was a fantastic artist. He would always talk about that drawing. He was really proud that he could contribute a drawing to the yearbook. The time that he was there [at Armijo] left an indelible imprint on him. People remember my dad because he gave of himself. Throughout his lifetime he touched many people's lives and made enduring friendships including people from his high school. I'm very proud that he is a part of Armijo history.

Johnny Colla: Heart and Soul of a Pack Rat

Class of 1969 Johnny Colla was a member of popular rock band Huey Lewis and The News, which had nineteen top-ten singles and sold thirty million albums worldwide. The band's tunes, many cowritten by Colla, are like a soundtrack to the '80s and include "Stuck with You," "Jacob's Ladder," "Do You Believe in Love," "Heart and Soul," "I Want a New Drug," "The Heart of Rock & Roll," "If This Is It," "Hip to Be Square," "Doing It All for My Baby" and many others.

In addition to being a saxophonist, rhythm guitarist, backup vocalist and songwriter, Colla is a self-described pack rat. Over the years, he has held on to numerous newspaper clippings and other items of personal significance.

In 1964, Colla saw trumpeter Louis Armstrong at Redman's Roller Rink in Fairfield and still has the jazzman's autograph. He shared three newspaper clippings from 1968 about the local band he was in back then, the Yewess Army. The first was published on March 5, 1968, and had the headline, "Campers Jump Gun in Hills Park Opening." The lede sentence read: "Hippies in Rockville Hills Park?" At least one local resident, Doug Machado, said he thought the park was invaded over the weekend by about 100 people, two of them he described as "hippie types."

> *I can't really remember exactly who was with me on this little excursion to the rock outcroppings on Rockville Road, just above the Oakville Road turnoff, but most likely it was a couple of Yewess Army bandmates, a couple of girlfriends and some hangers-on,"* Colla said. *"The article claims about '100 people, two of them described as "hippie types"' (gasp!), but I only remember there being about 10 to 12 of us. It also said that sheriff's deputies and a recreation supervisor showed up on Monday—a day late and a dollar short. Didn't they know hippies had to make a living, too?*

Colla pointed out that this spot was not the location of the later early to mid-1970s party location dubbed "Hippie Hill," which was closer to Rockville Inn near his brother's shop, the Dino Colla Salon.

The second clip was "Suisun Band Is Winner" from May 18, 1968. "Yewess Army Band, a rock group from Suisun City, won a third place trophy in the battle of the bands competition last Saturday at the Jumping Frog Jubilee and Calaveras County Fair at Angels Camp." They competed against fifteen bands. Another local, Fairfield singer Ted Schoenfeld, also won nine dollars in the talent contest.

Student Stories

Left: Class of 1969 grad Johnny Colla with a copy of the multiplatinum selling Huey Lewis and the News album *Sports* and the 1969 *La Mezcla* whose cover he created. *Christie-Claire Colla*.

Below: The Yewess Army 1968–69. *Left to right*: Jeff Pehan, Cary Schultz, Bill Yoha, Johnny Colla and Robert Koehn. *Linda Goering*.

"This would be my first road trip of many in my life. The Yewess Army were quickly becoming huge rock stars in our own minds. Only four years earlier The Beatles were crushing America and there I was in a van with my buddies. Those were heady, fun times. You think you have the best band in the world, you're meeting girls and you're traveling to far-off counties in California," Colla said. "What I like best about this clip is 'a rock group from Suisun City.' I was the only guy from Suisun. I must have handled the press upon our victorious return."

The third clip is headlined "Young Artists Paint Street," which is misleading, because it's talking about…well, vandalism.

> *Mrs. Joyce F. Schulz, 1209 Grant Street, told police six juveniles in a tan car stopped outside her house at 8 p.m. Using a street lamp for illumination, they sprayed the sidewalk and street with a can of orange spray paint.*
>
> *Among other graffiti found on the street was this memorial to servicemen "Yewess Army."*

"I had a crush on a young lady named Patti Murphy, so me and a few guys were hanging out at her place. I take 100 percent responsibility for this antic, and please consider this a formal apology to the city of Fairfield, California," Colla said. "It was a great time to grow up in Fairfield, and 1968 was a sweet spot in my life. It's hard to believe we were pulling off all these antics over fifty years ago and even harder to believe I actually later found success in my lifelong passion. I never would have guessed it, and to this day I still scratch my head."

Colla also still has his Armijo report card from April 1969. "I remember coming home and seeing the letter in my parent's mailbox, so I…liberated it. I got an A+ in Advanced Band and everything else was somewhere below a C-. I showed it to a friend of mine, Steve Keyser, and told him to get rid of it or change the 'F's to 'B's."

Evidently, pack rattiness is contagious, because Steve kept it and returned it thirty-five years later. "It's a reminder that I had ADD or ADHD or some other affliction that didn't have a name back then. My mom just said I had ants in my pants," Colla said. "It's a testament to the fact that just because you don't do well at everything doesn't mean that you won't excel at something."

Student Stories

Donna Covey: Painting Memories

Class of 1967's Donna Covey (pronounced "co-vee") loved art in high school, majored in art in college and later taught the subject, but she didn't indulge her own passion for it until 2008. Her first painting was a likeness of the old Iwama Market on Rockville Road.

Covey grew up near Iwama Market, and that painting led to her Suisun Valley series that features thirteen paintings, some watercolor, some acrylic, of her takes on local landmarks like Ledgewood Creek Winery, Manka's Corner, Green Valley Country Club and Thompson's Corner Saloon. "The Suisun Valley series was based on bike rides that me and several girlfriends

Cheerleader and, later, artist Donna Covey at a function in the gym with Rick Lowe of the band The Malibus. *1966 Armijo High Yearbook.*

Class of 1967 grad Donna Covey in front of some of her paintings. *Donna Covey Paintings*.

went on as kids," Covey said. "Because people liked them, I decided to work on projects from Fairfield and Suisun. I then did the Class of '67 series."

The first painting Covey completed in the Class of '67 series was of Sid's Drive-In, a hamburger joint that used to be located on the corner of Travis Boulevard and North Texas Street. "In high school I actually only went there once with a friend who could drive. I've always remembered that because we felt so cool," Covey said. "But the real hangout back then was Foster's Freeze (located where Yo Sushi is today). It was the next painting I did in the series. We'd cruise down West Texas Street past the high school and around the curve, then turn around at Foster's. It was the place to see everybody and be seen."

Covey's musings on other Class of '67 pieces:

Solano Drive-In Movie Theater: I tracked down the son of the original owner to get photographs, since it's no longer there, and they brought back so many memories.

The downtown Fairfield sign: The particular angle I chose shows Johnson's Bakery and also Hyde's Department store where I worked.

Joe's Buffet: I think it's changed now, but when I painted it a couple of years ago, Joe's Buffet still had the exact same front facade it did when I was in high school.

Covey paints in what is known as Contemporary Fauve expressionism style. "It's colorful and realistic, but it's an expression of realism," Covey said. "I'm not trying to render, say, Iwama Market to look exactly as it does."

Covey never thought she would sell paintings, much less have her own solo shows and people commissioning work from her. Covey's biggest supporter is Armijo classmate Jude Caulfield, who has purchased several pieces and whom she calls "a true patron of my art."

But it isn't just locals. The woman who bought the original Sid's Drive-In painting was from Las Vegas but connected with it on an emotional level.

Covey enjoys cropping photos of her subjects to settle on the one shot that creates an eye-pleasing composition. She then creates art that often features vibrant, arresting yet inviting colors and fanciful touches of whimsy.

Covey once had her work described as "bringing dead buildings back to life"—which she wasn't sure was a compliment—but the reaction her art usually receives is just what she is shooting for. "One of my main objectives is to make people smile," Covey said.

Brent Finger:
Purple and Gold to Red and Gold

When opportunity knocks, Brent Finger, aka Brent Showtime, always answers.

The Fairfield resident calls the fortuitous path his life has taken—where he has rubbed shoulders with celebrities such as San Francisco 49ers Joe Montana and Jerry Rice, Oakland A's slugger Mark McGwire and late artist Thomas Kinkade—his "Forrest Gump" moments.

Unlike the slow-witted Gump, however, Finger combined his natural entertainer instincts and advantageous connections to steadily grow his event-planning company, Showtime Productions, since its founding in 1989.

Finger moved to Fairfield after growing up in a tiny town in Iowa. While attending Grange Intermediate School and Armijo, he straddled the various social cliques—not the least of which was being a band geek (he was the drum major). "There were 'soulers,' who listened to soul music, and the rockers, but I was friends with both," Finger said. "I hung out with Kevin Harris, Pedy Banks, Chauncey Banks and others. They were just starting to DJ, and I got into it as well."

Finger started DJing at local parties, and one day opportunity knocked. "I had a neighbor who ran all the acoustic bands that walked around at tailgate

Brent Finger (*center*) with former 49ers coach Steve Mariucci and NFL Hall of Fame 49ers quarterback Joe Montana. *Brent Finger.*

parties at 49ers and A's games. The 49ers asked him if he knew anyone who was a DJ, and that is what got the ball rolling," Finger said.

Suddenly, Finger went from doing neighborhood house parties to a private fundraising event hosted by San Francisco 49ers Hall of Fame wide receiver Jerry Rice. That association with the team eventually led Finger to another job, as mascot of not one but two Bay Area professional sports teams. Off and on from 1989 to 2005, he shared the duty of being the 49ers mascot Huddles and later Sourdough Sam. From 1994 to 1996, he was also the Oakland A's elephant mascot Trunk. "Once you get behind that mask, you become that character. I did things in a mascot costume that I wouldn't do in my street clothes," Finger said.

Despite the costumes being hot and rather uncomfortable, Finger loved entertaining thousands of sports fans, and he and other mascots were treated like rock stars. "When Eddie DeBartolo owned the Niners, he would hire a limo for me, SJ Sharkie from the San Jose Sharks and Lou Seal from the San Francisco Giants and take us to places like the Garlic Festival in Gilroy," Finger said. "I even conducted the Berkeley symphony orchestra as Trunk."

Finger's company, Showtime Productions, started in 1989, and at first it was just a disc jockey business. He then began to see people needed things

at events such as tables and chairs and bounce houses and decided to offer those as well. These days, his company is a one-stop shop that has everything from inflatables to outdoor movie screens to machines that make foam for people to dance in at parties.

For over twenty years, Finger has hosted the official 49ers alumni pregame tailgate party. He does the music, brings in cheerleaders for fans to take pictures with and features past players such as Joe Montana and Dwight Clark. While some teams throw the word *family* around, Finger truly feels that connection with the 49ers organization.

Finger has been an integral part of Sober Grad Night events in this area since their inception in 1992 and was a member of the Fairfield Volunteer in Police Service before the COVID-19 pandemic. He met his wife, Irene, in 2010, and they have been married since 2012.

Despite hobnobbing with Hall of Famers and household names, Finger has never been starstruck. "It really wasn't until looking back recently that I realized how fortunate I have been to work with all the people I have," Finger said. "Behind closed doors, they are just normal people. They put their pants on the same way I do. It's just that when they do, they have more money falling out of their pockets than me."

Robert F. Hale: From Ranch Hand to Presidential Appointee

Robert Hale, who graduated with the Class of 1964, was raised on a fruit farm on land purchased by his great-grandfather, who came here from Michigan. "Our house was where the Anheuser-Busch brewery is now," Hale said. "I still own some land out there, and Hales have been on that property for four generations."

Hale went to Fairview Elementary and then to Armijo, where he excelled academically. He was president of the Math Club, a member of the California Scholarship Federation and was student body president. The latter came with a tragic responsibility in his senior year. "The day President Kennedy was assassinated, I oversaw the assembly where we had to tell everyone he had died," Hale said.

According to the 1964 *La Mezcla*, Hale was the first Armijo High winner of the National Council of Teachers of English Achievement Award, one of thirty-five in the state. Winners of the honor in the past had a 99 percent

record of acceptance into the college or university of their choice. Hale was no exception; after graduation, he attended prestigious Stanford University.

The Vietnam War was raging when he graduated from Stanford in 1968. At the time, there were two choices: go to Canada or enter the military. Hale joined the U.S. Navy. "I was a draft-induced volunteer, and as the Vietnam War drew down, I got out and went to a federally funded research and development center," Hale said. "It was a private company, but did a lot of work for the Center for Naval Analyses. That really got me into the analytics, and from there I went to the Congressional Budget Office, and that got me into the financial management side."

From 1994 to 2001, Hale was the comptroller and assistant secretary of the U.S. Air Force for financial management in the Bill Clinton administration. Then from 2009 to 2014, he was the comptroller chief financial officer for the Department of Defense in the Barack Obama administration.

"The Department of Defense is one of the largest organizations in the world. Its budget when I was there was in the $600 billion range, now it's around the $750 billion range," Hale said. "The fundamental job is to make sure we have the resources to meet national security requirements and also to make sure the money is spent consistent with the law and the extensive regulations that both Congress and the Department of Defense have set up."

The United States was in two wars during the five years Hale was with the Obama administration. Along with those requirements, there were peacetime obligations that needed to be met. "It was a chaotic period—we went through something called sequestration, where if Congress didn't like something they would cut it, which is what they did in 2013, and then shut the government down a few weeks later. It was a tumultuous period, but I learned a lot and it was the highlight of my professional career," Hale said. "I had oversight for all of the financial management and day-to-day contact with three Secretaries of Defense. I was there at 7:00 in the morning and didn't leave until 7:00 at night or later, so it was a very stressful job, but also very satisfying. I had a sense of being part of something bigger than myself, which is why government always appealed to me."

Hale is mainly retired now but still does part-time consulting and defense financial management projects. Over the years, he has received numerous awards, including the Department of Defense Medal for Distinguished Public Service, the Joint Distinguished Civilian Service Award from the Chairman of the Joint Chiefs of Staff and a joint award from the Government Accountability Office, Office of Management and Budget and

Student Stories

Class of 1964 grad Robert F. Hale (*third from right*) in the Oval Office with President Barack Obama. *Robert F. Hale.*

Department of the Treasury for distinguished lifetime accomplishments in federal financial management.

Hale came a long way from the fruit ranch in Suisun Valley. "I was scared to death when I went to Stanford because I thought, 'Oh my God!' I went to school in basically what was a rural area back then, but growing up on a fruit ranch you learn how to work, and that's at least as important as being smart," Hale said. "I certainly wasn't the smartest person at Stanford, but I did well because I studied a lot, and I think Armijo prepared me well for a competitive school."

Gary Falati:
Class President, Mayor of Fairfield

Gary Falati has the unique perspective of having been a student, teacher and administrator at Armijo High. On top of all that, he was the mayor of Fairfield for sixteen years.

Falati looks back fondly on his high school years. "I went to school in the old building that is now the courthouse," he said. "It had three stories, and the cafeteria was in the basement. Everyone congregated on the steps. Those were wonderful, exceptional times."

While Falati was involved in leadership for student government and the Future Farmers of America, he also took a leadership role in school pranks. "Chick Lanza [Wooden Valley Winery patriarch] and I hooked up in 1954 and have been good friends ever since. There was a stack of hay by the Ag department, and we caught a bunch of live mice from there and put them in bags. Then we took them to the third floor, and when the bell rang and everyone came out of the classes, we let them go. Omigod, it was unbelievable," Falati said, laughing.

Fairfield being a much smaller place then, news shot around town with rapidity that would put Twitter to shame. "If you got in trouble at school, your parents knew about it before you got home," Falati said. "We had good, clean fun, not vandalism-type fun. Really the worst that would happen would be when someone would say, 'What happened to Mary Jane?' Oh, she had to go 'visit her aunt' for nine months."

Falati attended Chico State, and while he wasn't sure of his career path, he decided to get a teaching credential, as teachers were always in demand. He later was a student teacher, ironically, at Fairfield High. He taught distributive economics in the mornings and ran the Fairfield aquatics center in the afternoons.

Fate came knocking on Falati's door one day, and it looked a whole lot like a friend he'd had since second grade, Tom Hannigan. "Tommy Hannigan suggested I run for city council," Falati said. "He had been on the council for years and been mayor, county supervisor and had got elected to the State Assembly. I did run and personally knocked on 8,600 doors. What really helped get me elected is that so many of those homes had kids who knew me from working at the city pool, the Fairfield Plunge."

While his city council campaign was a success, Falati got himself elected right out of a job, as it was a conflict of interest to be on the council and work for the city. He soon landed a position teaching business law as well as

Student Stories

Class of 1958 grad Gary Falati, who served as mayor of Fairfield for sixteen years. *Tony Wade.*

running the Regional Occupation Program (ROP) at his high school alma mater. "I loved teaching, and I just saw an old student of mine recently. I had him and others in freshman football, and we just hit it off," Falati said. "They were all in ROP and had jobs after school, and I remember when he and his friends all got accepted into college. They were outside my classroom, C-9, with wall-to-wall smiles."

Falati was still teaching when he was elected mayor but conducted no city business between the hours of 7:30 a.m. and 4:00 p.m., as he was on campus. He remembers one time having an important meeting with the owners of Solano Garbage on the bleachers at Armijo's Brownlee Field, because he was coaching freshman football.

"In 1979, then-principal Ken Perkins suggested I make myself available to be assistant principal, and I told him I didn't want the job. He said not to worry, because I wouldn't actually get it, but it would look good on my résumé that I applied for it," Falati said.

"So I was on vacation at Disneyland and I told him to just call me after the official decision and tell me when I officially didn't get the job. He called me up and said, 'You start Monday morning.'"

In 1983, a bit burned out, Falati left public office and school administration and started a new career as an insurance agent. He has now been with State

Farm for over thirty years. He contrasted his time on the council with the present day and also looked back on growing up in Fairfield. "We would have disagreements at the council meeting and afterwards we'd go to dinner at Dick's Seafood Grotto and have no animosity," Falati said. "You grow up in a community and the community matures and hopefully you mature as a person too. I know my roots here, and they are strong."

Kristina Yee: Award-Winning Animator

How does someone dead-set on becoming a lawyer become an animator? Well, in the case of Class of 2006 grad Kristina Yee, she can point to an older sibling.

"My sister was a year ahead of me and she had gone to a summer camp at Cal Arts, where she learned to animate," Yee said. "It was my first glimpse into that world, so by the time I was about to graduate, I had to ask myself if I really wanted to be a lawyer. It didn't sound as fun as this other stuff."

Yee had been honing her oratorical skills for future use as an attorney in the Debate Club, where she had been the captain of the team and president of the club. She was a self-professed nerd who loved learning and was involved in the International Baccalaureate program. Yee set her sights on going to Harvard University even when she was at Sullivan Middle School, and through her hard work at Armijo, she was accepted there. It was an eye-opening experience.

"There is a certain level of wealth and privilege that exists at Harvard. I came from a normal household, but some of the students there had parents who owned oil companies. That was a complete culture shock," Yee said. "But I settled in and adjusted to the environment with its huge amounts of academic pressure."

Yee majored in folklore and mythology, but art was still on the back burner as she made her way through college. She was the cartoonist for the iconic *Harvard Lampoon*. After Harvard, she attended the National Film and Television School in England, which she described as "pure fun."

Yee began making animated shorts and won a First Light Award for her piece on the Salem Witch Trials. But what gained her notoriety was a thirteen-minute film Yee created in 2013 that combined her vision and talents with those of some of her colleagues. *Miss Todd* told the story of Emma Lillian Todd, the first woman to design an airplane. Yee stumbled across Todd's story and knew she had to tell it.

Class of 2006 grad Kristina Yee making her short film *Miss Todd*, which won a Student Academy Award in 2013. *Kristina Yee.*

"I was going down an internet rabbit hole for something unrelated about early aviators and came across Lillian Todd and wondered why I'd never heard of her," Yee said. "I found her story interesting and mysterious."

Yee's creative vision was to tell the story of Miss Todd using stop-motion animation with paper puppets. In addition to detail-oriented model makers, she was able to enlist the help of other students who were composers. They contributed original music and songs, to which she added her own soprano vocals in spots. The real Lillian Todd never actually flew her creation, but Yee remedied that historic injustice artistically.

"I wasn't trying to present it as a pure biography, but as a jumping-off point. I was inspired by her story to take some artistic license and do some

revisionist history. It's a shame that she never actually got to fly, but in this film she does," Yee said.

Since shooting the film was a one-frame-at-a-time operation, the entire project took a year to complete. The attention to meticulous detail paid off, as *Miss Todd* won the Student Academy Award for a foreign film in addition to several other accolades and awards. It also was adapted into a children's book in 2014, *Miss Todd and Her Wonderful Flying Machine*.

After film school, Yee married a British man, and they made their home in Ireland, which has a blossoming animation industry. She has been involved in writing screenplays for animated and live-action features. She co-created and is showrunner (the person with overall creative authority and management responsibility for a television program) for a Cartoon Network Europe series, *Goat Girl*, set to debut in 2024. A comedy about a girl raised by mountain goats, it also features the underlying principle of embracing your quirks.

Next to her picture in the 2006 *La Mezcla*, Kristina Yee added a saying in French: "N'importe qui peut changer le monde" ("Anyone can change the world").

"I do believe that anyone can change the world and that we should be trying to do it." Yee said.

Maria White-Tillman: From the Armijo Joint Union to CNN

Two things were instrumental in Class of 1977 grad Maria White-Tillman's decision to become a journalist. One was writing editorials, covering sports and handling other features for the Armijo school newspaper, then called the *Joint Union*. The other was the living, breathing examples she saw on television.

"Valerie Morris was the anchor on KGO, and Belva Davis was on KTVU," White-Tillman said. "Those Black women journalists were my inspirations to pursue a career in journalism. They were well-spoken, beautiful, poised and smart—they inspired me so much."

After graduating from Armijo, White-Tillman earned her bachelor's degree in communication studies from Sacramento State University in 1982. She got valuable experience working on the Travis Air Force Base newspaper, the *Tailwind*, and as a general assignment reporter at the *Sacramento Observer*. She then worked as an intern newsroom assistant at KXTV Channel 10 before being hired at CNN in Atlanta in 1984.

Class of 1977 grad Maria White-Tillman at CNN headquarters, where she worked for thirty-two years. *Maria White-Tillman.*

While it is a news institution now, back in 1984, CNN was just four years old. "Other, more established outfits called us 'Chicken Noodle News' or 'College News Network,' but we knew we were on to something," White-Tillman said. "We had passion and dedication, and those were really fun days as we were forging a new path. It was a struggle to get into the White House press corps. We were the new kids on the block and had to petition and fight to get a seat at the table."

In her thirty-two years at CNN, White-Tillman was a part of its evolution. "We had twenty-four hours of time to fill, so in the beginning we took everything, from the cat in the tree to the squirrel waterskiing, but as we matured, we became more discretionary."

One of the things White-Tillman is most proud of was CNN's attention to detail in getting the story correct before reporting it. "Journalism is about

being factual. When Michael Jackson died, everyone was reporting it, but we waited to get confirmation from someone close to him like his publicist," White-Tillman said. "Your word is your bond, and people don't remember how many times you get it right, they remember the retraction when you get it wrong. We would rather be second and right than first and wrong."

In 1996, the Olympic Park bombing happened right across the street from CNN's headquarters, but covering it created an ironic situation. "It happened at 10:00 p.m. Eastern Time, and all of our crews had gone to bed, so we had to rely on video footage from our affiliate—which was a California news station," White-Tillman said.

Among the major news stories CNN covered during White-Tillman's tenure there were the Space Shuttle *Challenger* explosion, Hurricane Katrina, the death of Princess Diana, the Sandy Hook tragedy and the Oklahoma City bombing. The September 11 attacks on America, however, struck a personal nerve.

"The 9/11 attacks were scary because, at first, like everyone else, we didn't know what was going on. We locked the building and stopped the tours at CNN," White-Tillman said. "At my kids' school, parents were picking up their children in droves, and my kids told their teacher they were going to sit there because they knew I worked in the news and I would be working late."

While her journalistic drive comes from within, what motivated White-Tillman at Armijo was when she turned in her first story for the school paper and was told it was perfect by the newspaper advisor. For her work at CNN, her kudos came in the form of multiple National Academy of Television Arts and Sciences Emmys and George C. Peabody Awards.

Art Engell: Armijo Generations

Class of 1949 grad Art Engell, a longtime Fairfield real estate agent, made a diagram of all the members of his family who graduated from Armijo. It represented four generations, three of them still living.

The first Engell to graduate from Armijo was his uncle Clifford Engell in 1923, and the latest was his granddaughter Caitlin Engell in 2007.

When Art Engell received his diploma in 1949, Fairfield was a different place. "We lived in the country on Pennsylvania Avenue and Texas Street near where the Daily Republic building is now," Art Engell said. "We had five acres with chickens there, and Fairfield had less than two thousand residents."

Student Stories

At Armijo, Art Engell was involved in student government and literally grew into being an athlete. "When I started high school, I was four foot, eleven and a half inches, and when I graduated, I was six feet. I played basketball and tennis," he said.

When Engell was a bashful senior at Armijo High in 1949, he was horrified when some girls nominated him to run for class president against his friend Ernie Moretti (who later became Fairfield-Suisun School District superintendent). "We had to give speeches over the school loudspeaker. Ernie gave a superb speech—he was very sharp. When it was my turn, I said, 'This is Art Engell. I do not want to be president. Please do not vote for me.' I won," Engell said.

One of his duties was to speak at the Friday afternoon pre–football game rallies, and one day the students were stomping their feet boisterously. "I told the principal I couldn't calm them down. He said I had to do something. So I dismissed the whole school," Engell said. "I got in trouble for that."

Armijo's Class of 1949's most famous member was Nori "Pat" Morita, and Engell remembers the late actor and classmate as a friend. "I used to talk to him three or four times a year, and once we got him out to Mankas Corner with me and Ed Lippstreu and Ernie Moretti and a few other guys," Art said. "He came to our first class reunion, but then became too busy."

Class of 1975 Lory and Judy Engell's four sons, who all graduated from Armijo. *2004 Armijo High Yearbook.*

Art Engell's four sons, Lory, Ed, Randy and Donald, all attended Armijo, and the eldest, Lory, graduated in 1975. Lory Engell played football, basketball, golf and baseball at Armijo. A tie to his father's class was his coach, Ed Hopkins, whom the elder Engell described as being "a mean old booger on the court, but great for the kids."

"I played for Ed Hopkins and so did my dad. My dad's freshman year was Ed's first year as a coach, and I played for Ed when it was his last year of coaching," Lory Engell said. "I also played for Coach Leo Giovanetti, and so did my son when he went there."

Lory's wife since 1977, Judy, is a 1975 grad as well and the daughter of Armijo English teacher Darrell Anderson. She also became a teacher at the school before retiring. Lory and Judy have four sons who are alumni: Danny (1998), Brian (2000), Robert (2002) and Michael (2004). "The big difference between when my dad and I went to school and when my sons did is obviously technology," Lory said. "When I had to do research, I used an encyclopedia. I don't think my kids know what an encyclopedia is."

RUFUS BOWEN: A BEAUTIFUL MIND

For many laypeople, truly grasping the gift that internationally acclaimed mathematician and Class of 1964 Armijo High School grad Robert Edward "Rufus" Bowen displayed in his brief life probably requires comparisons to movies.

The kind of artistic mathematical genius Bowen possessed was portrayed by characters in based-on-a-true-story films like *The Imitation Game* and *A Beautiful Mind*, as well as the fictional *Good Will Hunting*.

Robert Bowen's older brother William was indirectly responsible for his younger sibling's abilities being discovered. "On the first day of my first class at the University of California, Berkeley, which was Calculus I, the professor asked how many had already had calculus. I was one of about ten people to raise my hand. He said, 'We have standards and generally I flunk half the class, so be prepared.' When I got a 'C' I was happy, but boy, was my dad upset. Thanks to his dumber older brother, Robert was immediately tutored in math by my dad," William Bowen said.

BOB BOWEN
guard

Class of 1964 grad and world-renowned mathematician Robert "Rufus" Bowen, who played basketball, tennis and baseball. *1964 Armijo High Yearbook.*

Despite his tongue-in-cheek self-deprecation, William Bowen was no academic slouch himself. The Class of 1959 grad, who was dubbed "Most Intelligent" in *La Mezcla*, is a retired professor emeritus of geography.

Robert Bowen was involved in math and science clubs at Armijo but was also student body president his senior year and played baseball, tennis and was on the league champion 1964 varsity basketball team. "[Legendary Armijo basketball] Coach Ed Hopkins once told me it was wonderful having Bob on the team because then he didn't have to worry about the rest of the guys screwing up their academics," William said. "When Hopkins asked Bob what he needed to tutor his teammates, he said a roulette wheel and decks of cards. He knew he had to get them interested in probabilities and statistics in a way they could relate to. You see, he wasn't just a gifted thinker, he was also an artful teacher."

Robert Bowen had essentially finished his entire undergraduate math studies at Berkeley by the time he graduated from Armijo. "I was five years older than him, but he got his PhD a year ahead of me," William said.

Robert's move from high school to college came with a transformation. "My brother hated his first name. He adopted the name Rufus when he went to Berkeley. Rufus is Nordic for red, and he had red hair," William said.

Rufus Bowen's meteoric rise—he attained a full professorship at age thirty and was a ranking lecturer and author on topics like dynamical systems—had a tragic fall. On July 30, 1978, at only thirty-one years of age, Bowen suffered a brain aneurysm while vacationing and died.

Celebrated English mathematician Caroline Series, professor emeritus in mathematics at the University of Warwick and president of the London Mathematical Society, shared remembrances of Rufus Bowen. "I got my first job at Berkeley partly because of Rufus, and there was a fantastic group there working on what you would now call Chaos Theory. I was young and trying to get myself established as an academic. Although he was young also, he was so brilliant and already had an international reputation," Series said. "I started working on a math project with him. I made what I considered to be a breakthrough so I called up his house very excited. I asked to speak to him and someone I didn't know answered the phone and said, 'He's dead.' It was unbelievable. He was a strong, healthy, athletic young man. The entire math community was devastated."

Series is certain that, had he lived, Rufus Bowen would have won the Fields Medal, which is awarded every four years to distinguished mathematicians under forty years of age.

He was honored another way, however. Since 1981, the Bowen Lectures, supported by anonymous donors, have been held annually at UC Berkeley. The groundbreaking work he did on dynamical systems is still being used and expanded on by mathematicians in climate modeling and numerous other areas.

Ramona Garrett: From Single Mom to Superior Court Judge

The path that Ramona Joyce Garrett traveled, leading to her becoming the first woman and first African American appointed as a Solano County Municipal or Superior Court judge, began when she was born in tiny Pine Bluff, Arkansas, in 1952.

Garrett was a military brat, and her family, including five siblings, moved frequently until her father retired at Travis Air Force Base in 1966. The curriculum Garrett tackled overseas in her pre–high school days was challenging, so when she enrolled in Armijo High that year as a freshman, she was advanced academically, if not socially. Garrett never committed 100 percent to her studies at Armijo, and as a sophomore she "discovered boys, and that became my preoccupation."

In January 1970, her senior year, Garrett was pregnant, and Armijo's policy was that expecting students had to leave when they began to "show." She still had enough credits to graduate but didn't walk with her class, as her daughter was born the day after the June ceremony.

Garrett began attending Santa Clara University three months after giving birth, and while she eventually graduated with a degree in philosophy, it wasn't easy. "I was eighteen years old on welfare with a baby at a wealthy school. I had to figure out how to be a grown-up. It was a formative experience. I learned I could deal with adversity and solve problems with very little assistance. It was my initial trial by fire," Garrett said.

After graduation, Garrett didn't know what career path to pursue and didn't realize the value of having a college degree. She held a string of jobs, including folding towels at Emporium-Capwell, being a counselor at Juvenile Hall and washing bottles in a refinery.

Eventually, Garrett craved more fulfilling work and enrolled at the University of California, Davis School of Law, from which she graduated in 1980. After passing the bar, she worked at a Vallejo firm for two years before taking a position at the Contra Costa County District Attorney's Office.

Student Stories

Ramona Garrett's junior yearbook picture. *1969 Armijo High Yearbook.*

Garrett discovered that she enjoyed the theater of the trial—being in front of jurors and talking about cases. At the district attorney's office, she learned and honed her craft, prosecuting misdemeanor and felony cases. She developed a technique there that helped her later, going to crime scenes in person instead of relying on photographs. "In a residential burglary case, a defendant said he'd been running through backyards in a neighborhood, so I went out to the scene and the houses were divided by high wooden fences. I asked how he'd managed that—was he a pole-vaulter?" Garrett said.

Garrett began working at the Solano County District Attorney's Office on July 5, 1984. "About the third week I was there, I had a burglary case and met the investigating officer whom I'd be working with. His name was Officer Arthur Koch [pronounced "coach"]," Garrett said. "We did the trial, I lost, we shook hands and he went on his way. I heard within a day or two he got shot. I was going to go visit him at Intercommunity Hospital, but the next day the paper said that he'd died."

Koch was the first Fairfield police officer killed in the line of duty. A double-amputee and Vietnam veteran named Stanley Verketis was charged with his murder. Garrett was assigned the case. "Only one other person in the office had ever done a capital case before," Garrett said. "I had to invent the wheel and create a prosecution from a manila file folder."

It took two trials and consumed the next three and half years of her life. At the first trial, defense arguments and testimony about Verketis's post-traumatic stress disorder from his time in Vietnam contributed to a hung jury. That tactic backfired in the retrial, as Verketis was seen by some jurors as being too dangerous to be in society.

After seven hours of deliberations, they found Verketis guilty of first-degree murder with special circumstances. On March 3, 1988, he was sentenced to life in prison without the possibility of parole. Verketis died in March 2017. "The verdict was gratifying because of what the case meant to Art's family, his colleagues and the people of Solano County," Garrett said. "I felt justice had been served."

Garrett took a month off after the case to heal, and once she returned she dove headfirst into a new position: chief deputy district attorney, managing

half of the attorneys in the office. After doing that job for six years, Garrett yearned to return to hands-on practice of law.

Her wish was granted on January 28, 1992, when Governor Pete Wilson appointed Garrett to the Solano County Municipal Court bench. She became the first woman and first African American appointed as a Solano County judge. The immense honor was muted by the hectic transition from prosecutor to judge. "There's no training; you're thrown into the cauldron," Garrett said. "I was fortunate to have had two outstanding judges in the Verketis case, and I modeled a lot of what I did on my observations of how they conducted themselves and ran their courtrooms."

Judge Ramona Garrett was appointed to the bench in 1992. *Judge Ramona Garrett.*

In addition to her municipal court caseload, Garrett began handling Solano County Superior Court cases. Eventually, the courts were consolidated in 1997. One of her notable accomplishments was establishing the Solano County Adult Drug Court, focusing on treatment instead of punishment. In 2007, Garrett was chosen by her colleagues to be presiding judge of Solano County Superior Court for 2008–9.

After twenty-three years on the bench, Garrett retired in 2015. In 2022, the Solano County Bar Association awarded her the first Legal Trailblazers Award. "When I was presiding judge, I was most happy to make the courts user-friendly so people could come into the system and have the administrative part work properly," Garrett said. "I'm gratified that I had the opportunity and privilege to serve the citizens of Solano County both as a prosecutor and as a judge."

THE LEGACY OF MATT GARCIA

The explosion of excitement when Matt Garcia was elected to the Fairfield City Council in 2007 at only twenty-one years old was equaled by the brutal anguish when he was murdered in a case of mistaken identity only a year later. Garcia's longtime best friend and 2004 classmate Scott Siordia shared memories of his influential late friend's time at Armijo and beyond.

Student Stories

Class of 2004 grads Chelsey Stanton (*left*) and Matt Garcia were voted Most Spirited in their class. *2004 Armijo High Yearbook*.

"I think it was sixth grade when I first met Matt. There was a dance with different middle schools, and he went to a different school than me then," Siordia said. "He was one of the smallest guys in the room, but he had the biggest personality. He always just had a presence about him that people gravitated to."

Garcia's aspiration to be a force in the community started before he was even at Armijo. "I remember in seventh grade he said he would eventually be the mayor of Fairfield, and we laughed at him," Siordia said. "But he started taking steps in that direction really early, like taking classes in conflict management and leadership and was serious about it."

A few years after graduation, Garcia ran for a seat on the city council. "I was there with him through the whole campaign, and in the final weeks I hated going anywhere with that guy because he knew everybody. If he didn't, he would shake their hand and look them in the eye, introduce himself and ask them what he could do to help them. It was amazing the amount of respect he got. He was always about making a positive impact."

Matt's mother, Teresa Courtemanche, remembered her son's aspirations. "As a child, Matt was very hyper. He had all these ideas and dreams and he told us he was going to be the mayor of Fairfield. Matt actually went to see then-mayor Karin MacMillan when he was in ninth or tenth grade just to find out how she got to where she did and what she did in her job. He was absolutely driven."

Interlude: Matt Garcia's Dream Lives On

On Monday September 1, 2008, we had our regular staff meeting at my former day job, Archway Recovery Services. I informed Executive Director Julie Lake that at the top of my to-do list was to contact Fairfield City Council members John Mraz and Matt Garcia about helping us with our fundraising gala in October. I told Julie I would call both of them the following day.

The next morning, I went on my daily walk and, on returning home, picked up the *Daily Republic* from my front porch. I couldn't make out what the headline on the front page said, because the paper was folded, but I knew it was a big deal because of the unusually large font size.

I don't think I can accurately describe my shock and horror when I unfolded the paper and read "Councilman Garcia Shot." I staggered into the house, told my wife and burst into tears. We got down on our knees and prayed.

After taking my daughter to school in a daze and heading to work, I called John Mraz, who confirmed that the situation was grave. Like many people, I held on to the belief that even though his injury was devastating, if anyone could beat the odds, it was Matt.

When I saw the news that Garcia was brain-dead, I was on the phone with my brother Kelvin and cried and cried. I left work and later joined equally devastated Fairfielders in front of the council chambers for a vigil.

I don't want to give the impression that I was a longtime friend of Garcia's, because I was not. But whether you knew him for a long time or bought into his infectious optimism when he ran for Fairfield City Council at the tender age of twenty-one, that isn't the point. Matt Garcia had the unique ability to make everyone feel like they were his special friend.

Kelvin had met with Matt for lunch when he was a candidate and conveyed to me that "the kid is the real deal." He said he had never met anyone with as much charisma as Matt, especially in someone so young. I was won over on meeting Matt, and when he pulled a miraculous upset in the election, I was elated.

I hope no one thinks I'm trying to put too fine a point on it, but I wasn't born when John F. Kennedy was shot. Martin Luther King Jr. was killed when I was four. So their assassinations and the enormity of the loss had no immediate effect on me. I'm certainly not trying to suggest that what Councilman Garcia accomplished in a short time in a mid-sized California city is comparable to JFK or MLK's achievements.

But the senseless theft of promise, the seeming extinguishing of the refreshing breeze of hopeful optimism that Matt's election ushered in and the incomprehensible shattering of future dreams that resulted from his murder is comparable. At least it is for me.

Matt Garcia's example deeply touched me. Keeping his dream alive is not just a slogan, nor is it just about the fundraising and other events that the Matt Garcia Foundation runs, fine as they are. What it means to me is that I keep foremost in my mind and in my actions that I love this city. It means that I will always strive to be a blessing and not a burden on my community.

Chapter 5
ATHLETICS

Down from under, under the thunder, Indians upon the field of play.
Let's all shout so they have no doubt that our hearts are with them all the way.
Never yield, down on the field, fight for victory and fame.
Go team! Fight team! Let's sweep the field clean! Show them how to play the game!
—"Down from Under," Armijo High School fight song

Armijo has produced numerous athletes guided by incredible coaches in sports as varied as gymnastics, badminton, volleyball, golf, cross-country, water polo, swimming and track and field. A comprehensive Armijo sports record book that detailed the myriad accomplishments of all the teams and individuals who have ever strived for glory under the purple and gold banner would be a most worthwhile project. However, that is not what this chapter represents. It is but a sampling.

In the early days, the sports facilities needed some serious attention. An editorial in the 1919 *La Mezcla* yearbook dissed the lack of adequate athletic facilities at the school, then on Union Avenue:

Do you know that when a student wishes to show a visitor around Armijo it is with a heart bursting with pride at the actual building itself, but when it comes to pointing out the grounds for athletics, it takes all the courage we possess to exhibit those grassy, rock bestrewn lots in the rear as our tennis and basketball courts which they are in name only as they are as good as nothing to play on. We sadly lack a good track. The only

place we have for them to work up any sort of speed is on the highway which runs past our school. I must say they have become very proficient in the art of dodging automobiles.

Track and field was one of the earliest sports that Armijo athletes competed in against other schools. The historical record in newspapers.com shows an 1896 meet against Woodland High School. A banner still on display in the Armijo gymnasium attests to the school's dominance. It lists championships from 1899, 1900, 1902, 1905, 1912, 1913, 1916 and then into the 1920s.

Minnie Meyer: The Fastest Woman in the World

Question: What do a world record in track, the Olympic trials and the U.S. Postal Service have in common?

Answer: Former Suisun City resident and Class of 1928 grad Minnie Meyer.

At a track meet in Sacramento on May 5, 1928, Meyer, then an eighteen-year-old senior, not only beat the reigning national 100-meter dash champion, Elta Cartwright from Eureka, but also broke the world record by running it in 12.03 seconds.

Meyer, along with three other young women, also shaved a second off the world record for the 400-meter relay at the same meet. A close friend and neighbor of Meyer's, junior Martha Scarlett, was on that team, and both were trained by teacher-coach Lois Carroll.

Meyer had started out running around an improvised track in a Suisun Valley orchard before being discovered by Carroll. They would sometimes go to Vallejo High School and use their rivals' track to train. Meyer's raw sprinting ability was honed, and she won twelve of the first thirteen races she competed in.

The *San Francisco Examiner* reported shortly after the record-shattering day in Sacramento that the residents of the "dual township of Suisun-Fairfield" (then approximately two thousand people) were abuzz with civic pride when news broke of the track results. Both the Fairfield and Suisun Lions Clubs contributed to a fund to defray the costs of sending Meyer, Scarlett and their coach to Newark, New Jersey, for the Olympic trials on July 4.

Several local and regional newspapers were confident that the Solano County speedsters would light up the world's stage at the Olympic Games that year in Amsterdam.

Newspaper article touting Minnie Meyer breaking the 100-meter dash record. *Fairfield Civic Center Library microfilm.*

Unfortunately, the world records set in Sacramento were later disallowed due to winds at the participants' backs. Still, in a later meet in Stockton, Meyer repeated her record-breaking time, proving that her speed owed more to her natural ability and rigorous training than the wind.

While numerous newspaper clippings and microfilm exist of Meyer's feat, curiously, her name is hard to find in internet searches. This is partly due to common misspellings of her last name as Myer, Myers or Meyers, and also because women's track and its record-keeping were in their infancy then.

On the day of the Olympic trials, Meyer did not run well and finished third. Since only first and second places were selected for the Olympic teams, she failed to qualify. Scarlett too came in third in the 220-yard dash and likewise failed to qualify. The relay team won, but they were informed that no relay team was going to Amsterdam. The Solano delegation visited Coney Island and Niagara Falls before heading home.

In 1939, Meyer began working at the Suisun City post office, where she stayed for nearly forty years before retiring. She was known for her kindness, attention to detail and strong work ethic. She only took ten days of sick leave in thirty-seven years.

Meyer married Stanley Smith in 1936 and raised her grandson, Suisun City resident Michael Boardman. In 1968, at Suisun City's centennial

celebration when Boardman was a teen, he ran into former Suisun City mayor and Armijo Class of 1942 grad Guido Colla. "Guido told me my grandmother was the fastest woman in the world. I didn't know what he was talking about," Boardman said.

He found out.

Minnie Meyer kept memorabilia from her track days, and Boardman still has several items, including trophies, newspaper clippings, photos and even the very shoes his grandmother wore in 1928 when she broke the world record.

Minnie Meyer Smith died on June 1, 1992, at the age of eighty-two.

Florence Griffith Joyner, who died in 1998, set the women's world record in 1988 for the 100-meter dash at 10.49 seconds, which stands today. But sixty years before "Flo-Jo," if only briefly, Armijo High's Minnie Meyer was the fastest woman in the world.

Football Becomes King

While it is now the undisputed king of high school sports, football didn't debut at Armijo until 1926. Class of 1927 grad Ben "Chalky" Oliver played on Armijo's first football team as the center. At 175 pounds, he was one of the biggest guys on the team. Years later, Oliver looked back on Armijo football's inauspicious start.

"We had all new uniforms, and they were the most ill-fitting things you ever saw. Those were the days of leather helmets with the ear flaps, and they were also ill-fitting. I used to wear mine for the first two plays of the game and then throw it off the field because I figured it was more dangerous to play with than without," Oliver said. "We didn't even have a real football field, it was all dirt. Before games, a freshman would go out with a fruit box and pick up bones and rocks so nobody would get hurt. I guess there used to be a slaughterhouse where the field was."

The first Armijo football coach was the school's principal, James Brownlee, who also taught classes. While his multitasking was admirable, perhaps he was a bit out of his depth. Armijo was just 3-5 his last year coaching them in 1929.

Enter Carrol A. "Buck" Bailey. Bailey was the assistant under Brownlee in 1929. Once he had the reins, the team took off. They peeled off ten straight winning campaigns in the 1930s, including four undefeated seasons and five Solano County Athletic League crowns. Armijo's overall record under Bailey's mentorship was 58-17-10. The football pinnacle was the 1936 squad.

The 1936 Armijo Football Team

The 1937 Armijo High School *La Mezcla* yearbook touted the achievements of its football team for the 1936–37 school year as "the most successful campaign the team has ever made." The yearbook's editors probably had no idea that statement would still be true more than eighty years later. The 1936 Armijo football team gave up just 12 points all season, only 6 by the first-team defense, and had seven shutouts, including five straight to end the season.

The only thing missing from the accounts of each game detailed in the 1937 yearbook is the iconic commanding narration from NFL Films' John "The Voice of God" Facenda accompanied by majestic symphonic music. "At the beginning of the season, little was known of the Indians' strength. The opening game found them battling on fairly even terms with the Vallejo Ramblers for three quarters. Then Coach Bailey's men put on an offensive drive that netted them two touchdowns in quick succession. The Fairfield boys trotted off the field with a 12–0 victory tucked under their belts."

They tied the Davis Blue Devils, 6–6, in nonleague play and then opened up league action by overcoming "extremely poor" field conditions at Rio Vista, hanging on for a 7–0 victory.

The next week's victim was Winters, who fell, 28–6. Armijo had built a substantial lead, so the second- and third-stringers played. A Winters running back busted a 60-yard face-saving touchdown run against the nonstarters. It was the second and last touchdown the Indians gave up all season. Armijo demolished Dixon next, 33–0.

Then it got serious. Two words: Vaca High. Cue the haunting theme from *The Good, the Bad and the Ugly*, and throw in some more yearbook hyperbole. "One of the largest crowds ever to witness a grid game in this town packed onto the field to watch the ancient rivals battle. During the first quarter, Vacaville seemed to have the edge over the Indians. However, a tired but happy group of gridders marched off the field on the long end of a 25–0 score. The dream of walloping Vacaville had come true."

The county playoff game was against Davis. The Indians ended up with 13 points and, as usual, hung a goose egg on their opponents. The Sacramento County Championships a week later was one of the hardest-fought battles of the year, but "the enthusiastic Armijo warriors" emerged victorious, 6–0.

Eleven starters played most games that season and included right end Kenneth I. Jones (whose father was a Fairfield school namesake), left end Fred Tomasini, left tackle Bob Hance, right tackle Anselmo Tocelli, left

ATHLETICS

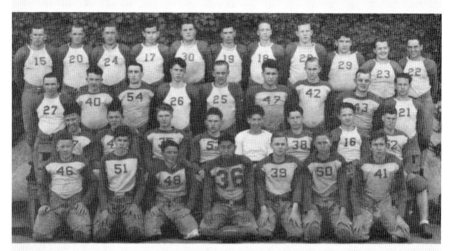

The 1936 Armijo football team is seen as the school's best ever. *1937 Armijo High Yearbook.*

guard Manual Campos (later a Fairfield city councilman and mayor), right guard Bob Spohn, center Bill Brownlee, left halfback Vincent Valine, right halfback Sidney Mack, quarterback Dick Harris and fullback Louie Colla (older brother of former Suisun City mayor Guido Colla).

Many players from the 1936 team and other dominant squads from the 1930s were in attendance when Armijo's football field was dedicated to longtime principal James Brownlee in 1955.

In the four score years since the Indians etched their mark on local gridiron history, the game of football has changed. Beyond the soft leather helmets, players are now much bigger than the 1936 squad. The tallest player then was six feet, one inch, and the heaviest was Campos, a stocky 212 pounds compacted onto a five-foot, eleven-inch frame.

On November 27, 1936, the Central California Championship game took place against Patterson High School. The yearbook speaks through the years: "The Indians went to Patterson determined not to muff this

chance for the highest honors any Armijo team had ever won. Although greatly handicapped by a 90-mile ride and a strange field, the Indians fought valiantly and swamped the Patterson boys with an 18–0 score. Thus ended the campaign of the most powerful football machine Coach Bailey has ever produced at Armijo."

Buck Bailey was also a very successful hoops coach, leading Armijo to four Solano County Athletic League titles and a 1939–40 Central Section basketball championship. Then in 1940, Bailey left and went to Woodland High School and built a legacy of greatness there, including having a basketball tournament bear his name, much like his successor at Armijo, Ed Hopkins.

Crosstown Rivalry

Fairfield High School broke ground in 1963 and started receiving some students in 1964. The 1964 Armijo yearbook contained a greeting/friendly challenge for the new school: "We encourage them to compete with us in a race for excellence in scholarship, citizenship, athletics and other worthwhile activities."

The Falcons could not compete with the Indians the first time the schools met on the gridiron in their annual crosstown rivalry game. It was November 10, 1966, and Armijo completely crushed the upstart school, 47–13. Newspaper accounts say that Armijo "utilized nearly every offensive play in the book" against Fairfield. It should be mentioned that Fairfield had a natural disadvantage. They had no seniors.

While the rivalry still doesn't have an official name, the Intra-City Trophy is given to the team that wins, and the year and score are recorded on it by red or purple plates.

A head-scratching entry in the crosstown contest was the 1986 matchup, which is on par with the Oakland Raiders' now-infamous "Tuck Rule" game. It took place at Fairfield's newly opened Schaefer Stadium. The game was deadlocked at 21–21 at the end of regulation. When the Indians scored in overtime, it set off a wild celebration. But according to some arcane rule, the extra period was only for the purpose of tie-breaking in case the teams were tied in the league at the end of the season, and so the game was recorded as a tie. If Armijo had won outright, they would have gone to the playoffs.

ATHLETICS

The Armijo football team at a home game. *1970 Armijo High Yearbook.*

WAYNE T. YEE: My senior year at Armijo, 1975, we won. It was not unexpected, since Fairfield High, if memory serves, hadn't won a game that season. The rivalry was always a big deal, except I think it was more like a sibling rivalry. We grew up and went to elementary and junior high school together, only to be separated in high school. I actually remember Web Berger (FHS class of '76) writing in my Sullivan Junior High eighth-grade yearbook: "Too bad you're going to Armijo, Fairfield could use you."

CLAY SHARPS: In the fall of 1977, Fairfield won the game. I was in the stands watching instead of playing in the game, due to disciplinary problems. It was one of my worst memories of high school—letting down my teammates and coaches.

CARL LAMERA: Back in the 1980s, the rivalry game was the biggest deal in the city. The *Daily Republic* would have write-ups every day leading up to the game. I remember one of the games at Armijo had over ten thousand people. People overflowed onto the track and the backs of the end zones. Ten thousand in old Brownlee Stadium was insane, especially when there was only seating for maybe four thousand. The most awesome thing was that there were never any issues. No stabbings, no gunshots and really no fights.

The Pizzarino Boys' Football Chronicles

The origins of the Pizzarino Boys are a bit unclear after more than six decades. Some believe the name was coined at Joe's Buffet, owned by Bob Lozano's father, and others at a spaghetti dinner at the home of Pete Andronis, whose parents owned the Airline Café.

The meaning? No one knows.

Defining what exactly the Pizzarino Boys were is a bit tricky, too. They were not exactly a club and certainly not a gang, with the connotations that word has today. Though labeling the group is difficult, two words succinctly defined them: jocks and pranksters.

The group included Jim Alexander, Jon Anabo, Pete Andronis, Emil Bautista, Bill Cupp, Gary Drummond, Mike Green, Keith Hayes, Bob Lozano, Dick Overturf, Gene Thacker and Bud Tonnesen. Tom Hannigan, a Fairfielder and longtime friend of the group who attended Armijo rival St.

Athletics

A picture of the Pizzarino Boys, drawn by Michael Green, in 1957. *Michael Green.*

Vincent's in Vallejo and later became a California state assemblyman, was an honorary member. As of January 2023, Alexander, Andronis, Bautista, Cupp, Hannigan, Lozano and Overturf have passed away.

The group kept in contact decades after they graduated from Armijo. They created the Pizzarino Boys Chronicles, a years-long hysterical email chain with stories of football glory and pranks from back when. The following are some highlights:

MIKE GREEN: I don't remember the date, and I don't remember our opponents. What I do remember is [quarterback] Anabo out of the pocket forced to run. As he approaches the line of scrimmage on a kind of end around, he confronts the tackler and straight-arms him. Unfazed, the tackler knocks Anabo flat on his ass, where he lays with his straight arm still extended in the air long enough to get laughs and rude comments from his teammates.

GENE THACKER: Guys, watching the weekend NFL games, the quarterbacks are constantly changing the plays at the line of scrimmage. I seem to remember that Jon would occasionally change our plays also?

MIKE GREEN: In the 1950s, Jon Anabo was a pretty sophisticated high school quarterback. Unfortunately, he became a power freak. He could force us to put ourselves in harm's way with a simple one-word command. As time went on, he changed plays for no reason other than to prove his superiority. Toward the end of our senior year, he didn't even share the word with us. He would come up to the line of scrimmage, check out the defense and shout out whatever word came into his head. Sometimes it was a noun, sometimes it was a verb, sometimes it was a name from the Old Testament and sometimes it was just a word he had missed on a French or Spanish vocabulary test. Each of the rest of us assumed we were the only one who didn't understand the command so said nothing for fear of humiliation. I'm glad I finally got it off my chest.

GENE THACKER: As the Benicia Rooters bus left Armijo it was pelted with eggs. Many of the pelters were the Pizzarino Boys. Did our Student Body President, one Mr. Jon Anabo, join in on the fun? I think I remember that Jon had to go to Benicia and apologize to their student body. True?

JON ANABO: As the former Student Body President of Armijo High School, I deny any and all charges placed before the jury. There is only one witness that testified for the prosecution, and his character is in question. I bought those eggs from Harry at Travis Market for the purpose of having a belated Easter egg hunt. Yes, I did go to Benicia to apologize. In fact, I still have the speech I had to deliver. Principal Vecchioni corrected my English, saying there is no such word as "prejudism." The Benicia student body did give me a standing ovalation.

MIKE GREEN:

> *Dear Mr. Anabo,*
> *First, as none of us were given an opportunity at the time, we would like to review the original text of your pathetic 1956 apology to the students and faculty of Benicia High School. In fact, we find the document should be a mandatory inclusion into* The Chronicles.

Secondly, as Mr. Vecchione (correct spelling) has passed away, we also find it necessary to continue his good work regarding your command of the English language. He was correct—"prejudism" is not a word. Neither is "ovalation"—did you mean to say "ovation" or perhaps "ovulation?" There would be a considerable difference in the response.
Keep up the good work,
Sincerely,
Pizzarino Literary Review Board

KEITH HAYES: Did Liberty High's Herman Urenda make a ninety-degree turn in midair? I recall seeing a lot of Armijo jockstraps littering the field after Urenda completed a run. Did I imagine that?

MIKE GREEN: It was real. I never did find my jockstrap.

The Marvelous Martin Brothers

In 2016, the Pro Football Hall of Fame published a list of brothers who have played professional football. At that time, there were 377 sets of brothers on the list, with more than 750 names total. Two of those were from Armijo, George Martin (Class of 1971) with the New York Giants and Doug Martin (Class of 1976) with the Minnesota Vikings.

While the two Martin brothers went on to fame both as defensive ends for their respective teams, they excelled at basketball and other sports at Armijo as well. George Martin put together three 400-point seasons playing hoops and thus is a member of the exclusive 1,000-point club with Mike Diaz, Dan Curry and a few others. But high school stats, impressive as they may be, have a way of being overlooked when you score a safety in the Super Bowl en route to winning it all, as George did in the 1986 season.

At Armijo, Doug Martin was a tackling machine, and at the 1975 Jamboree, which used to be an annual preseason scrimmage between the local high schools, he was named Outstanding Defensive Lineman. Before being drafted by the Vikings in 1980, he played collegiate ball for the Washington Huskies, where he helped them win the Rose Bowl in 1978. Doug Martin has the distinction of wearing purple and gold in high school, college and in the NFL.

George (*left*) and Doug Martin, Armijo brothers who both played in the National Football League. *George Martin.*

The Martin brothers' respective NFL teams played against each other only once, and unfortunately for Doug, it was November 16, 1986, when the Giants were in the midst of their dominating 14-2 regular-season run that would culminate in them winning their first Super Bowl. Still, it was a close game, with the G-Men winning, 22–20, at the Metrodome in Minnesota.

George Martin reached the pinnacle in the NFL with the Giants and was blessed to be on a team that not only had a Hall of Fame coach (Bill Parcells) but also Hall of Fame players (Lawrence Taylor, Harry Carson). Doug Martin was on several mediocre Vikings squads, and then, in 1988, when they went 11-5, he was on injured reserve. Still, he was picked in the first round, ninth overall, and in 1982 had 11.5 sacks and was named to the Pro Bowl.

In 2022, George Martin was inducted into the Sac-Joaquin Section Hall of Fame.

Vicky Valentine Proud: *The Girl Who Played High School Football*

In a 1973 issue of the school newspaper, then called the *Joint Union*, a column called Inside Armijo asked a few students, "Should girls be allowed

ATHLETICS

in boys' sports?" Most felt it would be OK if a girl were good enough. But the relevant part was that it was hypothetical.

That wasn't the case in the 1980s, when Vicky Valentine Proud played junior varsity and varsity football for the Indians. It was for real.

Proud, a lifelong tomboy, loved football for as long as she could remember. Her older brother J.R. would play neighborhood tackle games with high school friends, and she would join in. She was eight. Proud soon learned there is no crying in football. In addition to playing two-hand touch in the street and no-pads tackle in local parks, she collected football cards, had the electronic buzzing football game and was adept at Talking Football, a precursor to fantasy football.

After spending her freshman year at Armijo getting acclimated, Proud decided to follow a dream and try out for the football team. She was not the first. "I had a female classmate who went out in spring for the before-the-season workouts, but never made it to summer, much less to pads and the season," Proud said. "But she gave me the shot of courage I needed to go for it."

Proud is quick to point out that she was not a starter or even played that much. But when she got her number called, she gave it her all. What she lacked in speed, she made up for in grit. Proud played offense and defense and was not afraid of contact.

She never faced opposition from anyone for her decision to play a traditionally male sport and balked at any special treatment, such as a coach who offered her a head start in team wind sprints. Still, having a girl on the

Vicky Valentine Proud (*left*) as a member of the Armijo High Varsity football team (*center*), displaying her practice jersey and (*right*) on her wedding day with husband David Proud. *Vicky Valentine Proud.*

team required adjustments. "The first game I ever played in was when we beat Stockton 8–0, and I got to play in the last quarter to help preserve the win," Proud said. "Well, the guys thought it would be nice to let the lady shower first. Guys don't know much about girls because we take our time. The coaches started yelling, 'Hey! Are you done yet?!' And I yelled back, 'Hey! I'm shaving my legs! Sorry!'"

She also wore slightly different protective gear. "For protection I wore a sports bra—you learned to tie "the sisters" down so there is nothing for opponents to grab," Proud said.

In October 1986, she was present but did not play in the infamous game when Fairfield and Armijo went to overtime. The Indians were the only team to score, yet the game was ruled a tie, as overtime was only played in case it was needed to break a tie for a postseason berth. It still sticks in her craw.

Proud remains a die-hard football fan and roots for the Raiders. Still, she confesses to having a softer side. She likes "chick flicks," is a mother of two grown children and was married in 2010.

Basketball

Ed Hopkins: Coach of Coaches

In 1940, recent University of California, Berkeley graduate Edward Manley Hopkins was just about to accept a coaching position at Modesto High School. Fortunately, the UC Berkeley placement office called Armijo High School, Hopkins's alma mater, and learned of a similar position.

Modesto's loss was Fairfield's gain. For thirty-five years.

Ed Hopkins attended Crystal School and graduated from Armijo in 1933. He was an outstanding athlete and starred in football, baseball, basketball and track for all four of his high school years.

Just as he was starting to build a winning legacy as a multiple-sport coach at Armijo, World War II broke out. Hopkins joined the U.S. Navy, eventually becoming a lieutenant. He was assigned to the USS *Missouri*, nicknamed the "Mighty Mo."

In an October 14, 1945 front-page article in the *Solano Republican*, a letter he'd written to Armijo principal James Brownlee explained that while he wasn't on the *Missouri* at the historic moment when the war officially ended, perhaps he'd made some local history. "I wasn't aboard [the *Missouri*] at the time of the surrender ceremonies as I was taking part in a much bigger

ATHLETICS

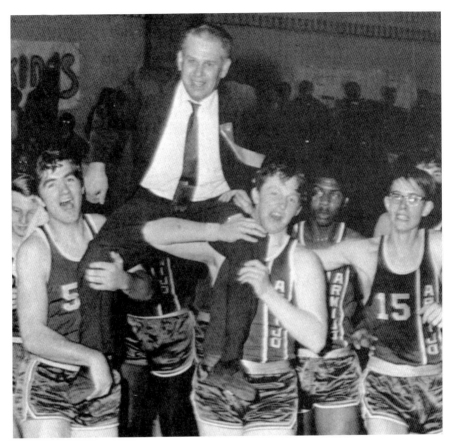

Legendary coach Ed Hopkins getting carried off the court (which would later be named after him) after his 500th win. *1970 Armijo Yearbook*.

thing, the occupation of Yokosuka Naval Base. I'll put a claim now to being the first Fairfieldite to set foot in Japan," Hopkins wrote.

In late November, an article titled "Coach Hopkins Returns Home" described his desire to jump right back into coaching after the war.

That he did. And then some.

Hopkins's 1950 basketball team won the league title. One of his players that season was the late Ron Thompson, who would become a legendary coach at Fairfield High School. The gym there is now the Ronald D. Thompson Gymnasium.

The 1952 hoops squad was a powerhouse, led by high-scoring Mike Diaz. That year, Armijo won 21 games and lost only 2. The average margin of victory was 19 points and the average margin of defeat only 9.

In 1954, the basketball team won the league title. One of the players was Jim Boyd, who later became a legendary coach at Vanden High School. The gym there is now the James L. Boyd Gymnasium.

The Indians were football league co-champions in 1955, the last time to date that they were gridiron champs.

Hopkins hung up his football coaching whistle in 1957 to focus on basketball. He had amazing longevity and coached his 500th game—a victory over Vanden—in the 1969–70 season. His players carried him triumphantly off the court on their shoulders.

Ed Hopkins retired from coaching in 1975. Altogether his teams (basketball, football, track and baseball) earned thirty-one championships. Dubbed "Mr. Basketball," his court record was 509 games won and 350 lost.

One of the most remarkable stats in Hopkins's career is that in thirty-five years of coaching hoops, he never received a technical foul.

The Solano Classic Basketball Tournament was renamed in Ed Hopkins's honor after he retired. While Armijo's gym had been named for E. Gary Vaughn, an Armijo grad who coached there before tragically dying of cancer, the floor is named, thanks to the efforts of then principal Rae Lanpheir and Armijo athletic director Jay Dahl, Ed Hopkins Court.

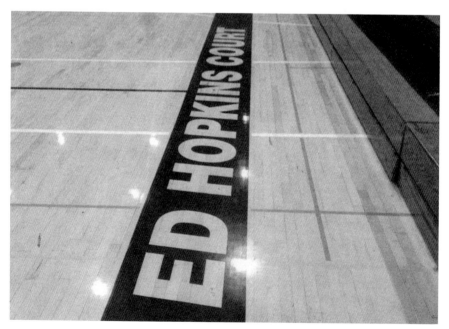

Ed Hopkins Court, which was named in honor of the legendary longtime Armijo coach. *Tony Wade.*

Athletics

On July 4, 1988, Ed Hopkins died of a heart attack. Years later, efforts by many locals to have a new high school named after Hopkins failed, and it became Angelo Rodriguez High School. However, the football stadium, dedicated in 2009, is Coach Ed Hopkins Memorial Stadium.

Hopkins was universally respected and admired, not just for his coaching ability but for being a warm, humble, inspirational human being with a great sense of humor. His coaching tree has numerous branches—no less than thirty-five of his former athletes became coaches themselves.

Jay Dahl: A Falcon Becomes an Indian

Armijo basketball coach and athletic director Jay Dahl was born in San Angelo, Texas, and his father was in the U.S. Air Force, which brought his family to Fairfield. Shortly thereafter, tragedy struck. "We got here in December of 1965. I turned fourteen in January of 1966, and my dad passed away in March," Dahl said. "We had just purchased a house, and my mom was thinking about going back to Milwaukee, where both she and my father were from, but my three siblings and I talked her into staying here."

Dahl was tall for his age. Or any age. "When I walked into my eighth-grade classroom at Anna Kyle [then kindergarten through eighth], I was six foot, three inches, and everyone thought I was a student teacher," Dahl said.

Later, at the still-new Fairfield High, Dahl played varsity basketball as a freshman. His coach was Ron Thompson, who had come over from Armijo, where he ran the junior varsity squad under legendary Indians coach Ed Hopkins, who handled the varsity. "We had very good teams. We were in the old Delta League [Woodland, Davis, Armijo, Vacaville, James Marshall and Galt], and our biggest rival was Davis," Dahl said. "I was six foot, nine inches as a senior and got a scholarship to the University of the Pacific."

Originally, Dahl sought a career as a dentist, but after receiving *C*'s in classes he had excelled at in high school, he quickly formulated a plan B: to pursue a degree in physical education and become a coach. "In 1975, I started at Bransford Elementary School. I had met and became close friends with Armijo coach Leo Giovanetti at the rec department, and he'd taken over as head coach when Ed Hopkins retired," Dahl said. "I could have gone over and worked with Ron Thompson, but I had played with him for four years and wanted to learn some different things, so I taught at Bransford and coached at Armijo with Leo."

Armijo High School

Basketball coach Jay Dahl spelling out strategy to his team during a game. *1986 Armijo High Yearbook.*

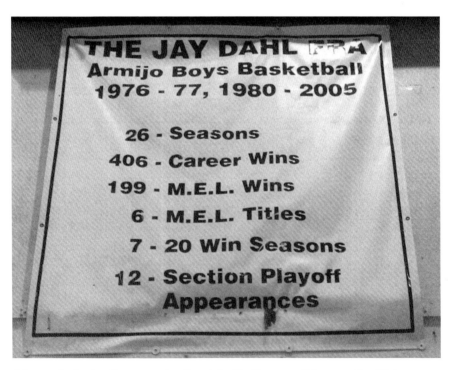

A banner in the Armijo gym touting Coach Jay Dahl's accomplishments. *Tony Wade.*

During his time coaching, Dahl was both JV and varsity coach and later became the athletic director. For years, the school's administration expressed their desire for Dahl to come over from Bransford and teach and coach at Armijo. He eventually did and regrets not doing it sooner. Still, he made good use of his connections with the Armijo feeder school by bringing Bransford kids to Armijo sporting events. "I was trying to expose kids to high school sports—football and basketball games. I had some really good athletes who came through Bransford that looked up to and admired the high school kids," Dahl said. "Some of the kids that went through there like Huck Flener later played basketball, football and baseball at Armijo and wound up playing baseball professionally."

Dahl's 1993–94 squad went 23-5 and were the Monticello Empire League champions, going 13-1 in league play. The 23 wins broke the school record set in 1954 and was the first outright crown since 1968. Clutch shooting, tough rebounding, excellent free-throw shooting and a team-first spirit led the Indians to the school's first appearance at Sacramento's Arco Arena in the section playoffs.

Dahl's last year at Armijo was 2005, and at his retirement dinner at Pepperbelly's Comedy Club, he surprised several former players in attendance by presenting them with their old varsity jerseys.

He also shared a funny remembrance. "We were playing Vacaville in the 1980s, and they were about to announce the starting lineup, and suddenly a shopping cart came flying out of the back corner where the team locker room was, with the Vacaville bulldog in it with arrows stuck in it," Dahl said. "When I came in Monday morning early to turn on the heat before practice, I turned on the lights and discovered black dog paw prints painted all over the bleachers and the floor, and our rims were missing. That was our payback."

Coach Dahl now enjoys golfing and spending quality time with his grandchildren. He takes a big-picture view when looking back on his coaching career. "The best part of coaching isn't the winning or losing; it's working with the kids. When I was fourteen and had the experience I had with losing my dad, Ron Thompson was a very big male influence on me and I tried to do the same thing with other kids. If I could help just one kid out a year, that was a big deal," Dahl said.

Baseball

Dave Marshall: A Baseball Life

Armijo's baseball "field of dreams" is named after Dave Marshall, a man who lived and breathed America's pastime. He passed his vast experience on to numerous young men during his tenure at Armijo—and captured six Monticello Empire League (MEL) titles in the process.

Marshall grew up in Vallejo and was an outstanding first baseman. At St. Vincent's, he was an all-league selection. After high school, he was named the MVP of the Solano College team in 1969. That same year, he was drafted by the San Francisco Giants.

"It was the era of the Vietnam War, and my decision was to stay in school. I was also offered a contract by the Dodgers, but I was getting married at that time," Marshall said. "Professional baseball never worked out, but I am grateful and enjoyed my life and had a great family."

Marshall's diamond prowess can't be overstated. In fact, he later played for the Chico State Wildcats for two years but was still named Athlete of the Decade for the 1970s.

Before coming to Armijo, Marshall coached at St. Patrick–St. Vincent, which captured their first Catholic Athletic League Championship in 1979. Then, in his first year at Armijo, that school won the MEL and repeated the accomplishment in 1989, 1993, 1997, 2000 and 2001. "The first championship was exciting. We focused on one game at a time. Our motto was like [Marshall's old friend] Tug McGraw's from Vallejo. 'We believe.' Believe in yourself. Go out and just play pitch for pitch, out for out, inning for inning, one game at a time."

Marshall is quick to point out that it was not a one-man show at Armijo. Having strong, well-coached freshman and frosh-soph programs created much-needed continuity and taught the fundamentals they wanted players to have at the varsity level.

When Angelo Rodriguez High School opened in 2001, Marshall made the difficult decision to leave Armijo and become the new school's athletic director and PE teacher. He looked forward to the challenge of building all the school's sports from the ground up as well as an entire PE program. Marshall later went back to school and got an administrative degree and became a vice-principal at several schools in the district and then finished his educational career as principal at Crystal before retiring in 2011.

Marshall was honored for his decades-long baseball coaching and playing career in three different halls of fame: the Solano College Sports Hall of Fame, the St. Patrick–St. Vincent High Sports Hall of Fame and the Vallejo Sports Hall of Fame. At the dedication of Dave Marshall Field at Armijo, nearly every coach he had ever had from Little League to college was present.

Although he is proud of his accomplishments and the accolades they elicited, Marshall treasures other things above the final tallies of runs, games, titles and championships. "The relationships that I and other coaches had with the players and their amazing supportive parents are what sticks out, and I will never forget them."

Huck Flener: First Fairfielder to Play Major League Baseball

Class of 1987 grad Gregory Alan Flener was called "Huckleberry" by his dad at birth and the nickname "Huck" stuck. When he attended Bransford Elementary School, his PE coach, Jay Dahl, would take him and others to Armijo, where Dahl coached, to be ball boys. "I was an Armijo rat for a long time before I even attended the school. I would sneak into football games when I was six, and I went to every Armijo basketball or football game I could," Flener said.

Flener played T-ball with the Fairfield Recreation Department and Little League. His team was the Fireballs, sponsored by the Fairfield Fire Department. "When I help kids now, I tell them that I really wasn't allowed to pitch until I was 12. I couldn't throw a strike to save my life," Flener said. "I was blessed with a pretty good arm from the jump and by the time I was 11 I should have been one of the better pitchers, but they would put me in and I would walk everybody and they would take me out."

But with practice and coaching, he improved. When he was a freshman at Armijo, Flener started out on the JV team but was elevated to varsity. "I was ready to play outfield at that level, but I wasn't ready to hit. I did have an RBI triple against Fairfield High that won the game, though. I squared one up and smoked a triple at Allan Witt Park," Flener said.

Baseball coach Dave Marshall recognized the goods when he saw them and told Flener that he could play baseball beyond high school if he wanted, which was the first time Flener began to believe it. Marshall asked him where he might want to play, and Flener replied, "Cal State Fullerton." "At that time, Cal State Fullerton had just won the National

Championship, and he laughed when I said that. But what's funny is I ended up getting a full ride scholarship there," Flener said.

In the mid- to late 1980s, Cal State Fullerton was still a baseball powerhouse, and in Flener's freshman and junior years, they went to the College World Series but didn't win it either time. On the day they were eliminated from the series the second time, Flener experienced a roller coaster of emotions. "I pitched eight innings and we went twelve, and we got eliminated. I didn't know that my dad had flown to Omaha to see me play, and he kind of surprised me," Flener said. "Then I went back to the hotel and there was a telegram saying I had been drafted by the Toronto Blue Jays. I went out and had a beer or two with my dad."

There began a long saga of mini camps, rookie ball and the weeding out and honing talent process to develop raw players into Major League Baseball material. During those years, one thing that Flener was able to develop and add to his pitching arsenal was a changeup.

In September 1993, Flener got the call-up to the majors, which he described as "surreal." He went to Detroit and instead of napping spoke with *Daily Republic* sports editor Jon Gibson on the phone about the news. Unfortunately, in all the excitement and lack of sleep, Flener left his gear bag with his cleats, glove and other equipment at the hotel, which was forty-five minutes from Tiger Stadium, and he didn't realize it until it was almost game time. "I used Al Leiter's backup glove, and Pat Hentgen let me borrow some old cleats that were too big, but they were close enough. Then the clubhouse manager said they were only supposed to have two guys called up, Shawn Green and Carlos Delgado, and neither were there yet, but those were the only two jerseys they had. Carlos Delgado was a monster, so that wasn't going to happen, so in my major league debut the back of my jersey said Green," Flener said.

The Blue Jays were in a pennant race, and the game was going back and forth. Flener was relaxed, or as relaxed as he could be in someone else's cleats, because he was told he wouldn't be pitching that day. But with the Blue Jays up, 6–5, in the bottom of the eighth inning, their pitcher gave up a single and then

A baseball card featuring Toronto Blue Jays pitcher and Class of 1987 grad Huck Flener. *Tim Farmer collection.*

hit the next batter. Facing two outs with runners on second and third, Flener was called in to pitch. Despite only being half warmed up, he got Detroit's Chad Kreuter to fly out to center field. Then Tony Fernandez hit a three-run homer in the ninth to win the game for the Jays.

Being in the same locker room with players like Paul Molitor and Dave Stewart, whose baseball cards Flener once had, was indescribable. The team won the World Series that year, and Flener has a ring, but it is bittersweet. "That was the series where Joe Carter hit the walk-off home run. When it came playoff time they called me in the last day of the season and asked me to go to Venezuela to get more training. I got a ring because technically I contributed, but I wasn't there when Joe Carter won it. I was in Venezuela."

Through injuries and countless games, it took Flener three more years to make it back to the majors. It was tough, brutal and glorious, and his Major League Baseball experience is one that he now looks back on and treasures. "I went through a lot of blood, sweat and tears," Flener said. "It's a whole different experience if you're Steph Curry rather than the last guy on the bench that's a journeyman player. I was that journeyman."

Softball

Peggy Linville: Domination

Armijo coach and PE teacher Peggy Linville, who worked at the school from 1970 to 2001, shepherded several squads of women to softball glory, with the greatest being the 1978 team. That team was an undeniable powerhouse that steamrolled the Monticello Empire League on the way to a 23-0 record and a state championship.

The win is even more remarkable because in the biggest game, the Sac-Joaquin Section Tournament of Champions finale, when it all was on the line, the Indians were not at full strength. "The day before the championship there was a disciplinary issue and I had to make the hard but correct decision to bench two of our crucial players. I told the team that we were going to go out there and do the best we could. I actually had to put the scorekeeper on second base because we didn't have enough players," Linville said. "It was one of the hardest things I've ever done."

The Indians were facing Bella Vista of Fair Oaks, who were the defending champions. It had been a back-and-forth affair, and when the dust settled,

VARSITY (back) Vanessa Paschal, Monica Florez, Maggie Scholl, Iva Jackson, Jenny Moorhead, Diana Sanford, Bobbie Sykes, Connie Wright (front) Chris Roybal, Kathy Stow, Rhonda Clarke, Debbie Poole, Cindy Retherford, Margaret Sutter.

The 1978 softball championship team led by coach Peggy Linville that went 23-0. *1978 Armijo High Yearbook.*

due to a timely triple by Iva Jackson and a game-winning grounder by pitcher extraordinaire Margaret Sutter, the Indians emerged victorious, 5–4. "It was a good teaching lesson to stand your ground and to show them that we had to buck up and do it. It was so heartwarming," Linville said.

While she credits the strong players she was blessed with at Armijo, marshaling that talent and focusing their drive is where exceptional coaches come in. Linville was named coach of the year, and that 1978 team was no fluke. Two years later, they won the Sac-Joaquin Section title again and captured MEL titles in 1977, 1978, 1980 and 1983.

In her thirty-one years at Armijo, Linville coached field hockey (which she loved, but was cut), basketball (which she did not love, because she "is pushing five foot, one") and volleyball and took over badminton when her friend and colleague Karen Meek retired.

Linville has a black belt in karate and Kobudō (Okinawan weapons-based martial art) and keeps in shape these days by boxing with a trainer.

One lesson Linville always tried to practice, which served her well, was, "If you respect students, they will respect you."

Cindy Retherford Brown: She was a great PE teacher and coach, but an even better example and person. She had a great influence on me when she was willing to make ethically correct decisions even if it was hard. I love her!

Rozanne Helms: I remember Miss Linville! She was very kind and encouraging to those of us who were (to put it mildly) not athletic.

Suzanne Goodwin Stenberg: Ms. Linville showed me the importance of my contribution to our team. I definitely was not the greatest player, but she pointed out my strengths and how I made a difference in other ways. I have used her words of wisdom to other kiddos who might not be the star of the team but help in their own ways to make their teams stronger.

Wrestling

Ron Cortese: Grappling Greatness

Ron Cortese was born in Arkansas in 1942 and attended high school in Martinez, California, and college in Oregon. He loved sports and played many, and he began his coaching career at Armijo in 1968. Cortese has coached just about every sport there is, but wrestling holds a special place in his heart. "Wrestling was a great love of mine, and it's the only sport where the competitors are of equal size," Cortese said. "I'd see these five-foot, two-inch, ninety-eight-pound guys and ask them if the football or basketball coach had talked to them, and when they said 'no,' I would tell them, 'Well, I've got a place for you.'"

Under Cortese's tutelage, the Indians had several lightweight wrestlers who excelled, including John Silva and Joe Taylor. One standout was heavyweight Michael Burgher. "Michael Burgher won three league championships, and he probably would have won four, but I didn't let him wrestle his freshman year because there was a senior there and I thought it was the seniors' time," Cortese said. "He went on to Palomar Junior College and won the State Championship there, then went to UCLA and won the Pac 8 Championship.

Left to right: Armijo coaches Bill Fuller (tennis, football), Leo Giovanetti (basketball) and Ron Cortese (wrestling) playing a basketball game against coaches from Fairfield High. *1975 Armijo High Yearbook.*

I watched him wrestle Olympic champion Lee Kemp, and he scored points, but lost. He was probably the most talented kid who came through Armijo, but we had lots of great champions and lots of good wrestlers."

The Armijo High School Invitational Tournament, founded by Cortese, has been going strong for decades. The controversial decision to dump wrestling from a competition, where it had been a staple for much longer (dating to the original Olympics) stunned the former Armijo coach. "It was the oldest sport in the Olympics besides running. I'm heartbroken," Cortese said. "I think Olympic wrestling hurt itself with some of the changes they made. It was different from scholastic wrestling. In Olympic wrestling, there are three rounds, and you have to win two out of three. So if I beat you in the first round 1–0, I win that round. If you beat me 12–0 in the second round, you win that round. But if I beat you 1–0 in the third round, I win the match even though you have outscored me 12–2! That's wrong."

One memory he had was of a wrestler who was on the team for only his senior year, 1977. "Orvis Wade was wrestling a heavyweight opponent from Vacaville, and the Bulldog had him on his back, so Orvis basically benchpressed the guy onto his back, then dug his chin into his chest and pinned him. It was incredible," Cortese said.

After retiring in 1999, Coach Cortese stayed busy officiating various sports, and he and his wife, Sharon, were tireless community volunteers. They helped with everything from Meals on Wheels to ushering at the Downtown Theatre. Their efforts were honored by both Fairfield mayor Harry Price and Congressman John Garamendi.

Coach Cortese looks back fondly on his time at Fairfield's oldest high school. He reflects on the wonderful booster club the school had and how nice it is to see former students contributing to society around the world and especially at home. "It thrills me to see our people staying here and contributing as adults," Cortese said. "Armijo was the perfect setting for me."

The "Sons of Cortese"

Rick King, from Armijo's Class of 1976, is part of a group of former Armijo grapplers unofficially called "The Sons of Cortese." Most of them hailed from Suisun City and were on the wrestling team in the 1970s. They have stayed in contact and have had an annual reunion weekend in Lake Tahoe for over thirty years.

King and his friends would hide behind corners in downtown Suisun but would inevitably be spotted by older kids, who would jump them and use some of the moves they learned on the wrestling team on them. "One day, Joe Taylor tossed me to the ground and tore my jeans. I was twice his size but couldn't get him off me. I got sick of it and decided to join the wrestling team," King said. "That's what inspired me and some others to join—those butt kickings on the sidewalk."

Rick King's brothers Reynaldo (Class of 1975) and Ricardo (Class of 1977) were on the team as well. They all had a certain scrappiness they had developed before they even moved to California. "We grew up on Sidi Slimane Air Base in Africa near Morocco. There were some really rough kids there that we would sometimes have to fight including Africans, Arabs and Algerians," Rick King said. "I'm talking about six-year-olds who were smoking cigarettes!"

When they joined the team, some of the high jinks they would engage in while participating in the ancient real sport of Greco-Roman wrestling were moves they saw popularized on the sports entertainment *Big Time Wrestling* shows. For instance, one Son of Cortese, when he got behind on points, would start stamping his foot on the ground to "load his boot" the way the Iron Sheik used to do on TV. "My specialty was making up my own

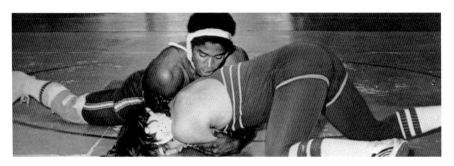

Stellar wrestler Michael Burgher performing his grappling magic on the mat. *1975 Armijo High Yearbook.*

moves. I learned that every wrestling move had a counter-move, and I would watch a couple of guys who knew each other well wrestle sometimes and not score a point because they knew what the other guy was going to do," King said. "So I would watch contortionists and read books on judo and come up with new moves that would drive guys crazy because they wouldn't have a counter for it."

Some of King's wrestling compatriots included Michael Burgher, Skipper Lightfoot, Mark Bonnett, Tony Cruz, Lucky Cruz, Gray Cruz, Bob Germany, Peter Padilla and Frankie Estrada. A few have passed away. "Ed Van Diemen passed away a few years ago. He was the heart of the team. He wasn't the best wrestler, but he never ever quit. He would wrestle anybody. He was a scrapper. Fearless," King said.

The Lake Tahoe get-togethers involve hanging out, catching up, drinking, golfing, eating, storytelling, usually some wrestling and much laughter. A measure of how much fun they have had is that, once, the sheriff escorted them to the edge of town with the instructions never to return. They skipped one year but resumed the year after that.

King received unsolicited validation from Coach Cortese a couple of years ago. "Coach said that we drove him crazy, but when he looked back on it, those were the best years of his life," King said.

Girls' Athletic Society

The Girls' Athletic Society (GAS) was started in 1926. Like Block A for boys, its goal was to increase participation in sports. It was the campus authority by which young ladies received a letter for their athletic achievements.

Girls participated in sports like track and field and basketball early on and were playing baseball a generation before the women depicted in the movie *A League of Their Own*. They also participated in, and in many cases excelled at, badminton, volleyball, Ping-Pong, tennis and others. In the 1950s, one rather odd entry in the GAS list of athletic activities was folk dancing. While there is definitely an art to performing any sport well, it is not clear whether that alone makes an art an actual sport.

The Girls' Athletic Society was still a thing as late as 1988, as that year's yearbook reported them as sponsors for the Sadie Hawkins Dance. No doubt their influence helped many young women get involved in sports teams at the school. Take wrestling, for example. The 1983 *La Mezcla* reports: "The Wrestlerettes are an important part of the wrestling team. They are the official scorekeepers, keeping stats, team records and taking care of the display windows."

In the 2022, *La Mezcla*, seven of the twenty-three members of the actual wrestling team were female. No "ettes" suffix was needed.

A Few More

Numerous other teams and individual athletes distinguished themselves in different disciplines over the years. Again, the following are just a representative sample.

Armijo championship banners. *Tony Wade*.

Armijo High School

Left: 1977 gymnastics champions. *1978 Armijo High Yearbook.*

Below: Class of 1987 Armijo hurdler Clara Trigg. *1985 Armijo High Yearbook.*

ATHLETICS

Girls Basketball

Back in 1924, Elvie Witt, older sister of Fairfield barber and park namesake Allan Witt, dropped 33 points on Vallejo, setting a school record that stood for seventy years until finally matched by Michelle Muir in 1994.

In seventeen seasons at Armijo beginning in 1984, girls' basketball coach Bob Pickett's squads won two MEL titles and made eight playoff appearances, going 239-206.

Gymnastics

The 1977–78 Armijo gymnastics team, coached by Tina Preston and Joan Geel, won Armijo's first Sac-Joaquin Section title in only the second year gymnastics was contested at that level.

Tennis

Bill Fuller, who also headed up the football squad for years, coached the Armijo tennis team to their first two Sac-Joaquin Section team titles, in 1982 and 1983.

Greg Davis was the winningest coach in the tennis program's history. His boys teams won twelve Monticello Empire League titles, including a streak of eight in a row, and reached the Sac-Joaquin Section semifinals eleven times and the finals in 2002 and 2010.

Cross-Country and Track

Coach Dave Monk's teams provided the school with an embarrassment of riches: one MEL boys and four MEL girls track titles; two Sac-Joaquin Section boys and four Sac-Joaquin Section girls track titles; and four MEL boys' and two MEL girls' cross-country titles. His 2006 girls track team finished fifth in the CIF State Championships.

Chapter 6

THE ARMIJO SUPER BAND

Armijo's first school band, made up of fifteen students, was organized by William F. Newell in 1926. They were a ragtag bunch at first but were whipped into shape and, by the spring of 1927, entered a music contest in Santa Rosa, where they took third place. In 1928, they were invited to play live at San Francisco Radio Station KGO. In a yearbook picture, their crisp white uniforms and hats resemble those of the Good Humor Ice Cream man.

By 1932, the orchestra and band had played on Armistice Day at the Armijo Auditorium and provided music for several plays, and a new seven-member string ensemble played at Lions Club meetings. They also performed at basketball and football games, as well as the commencement exercises in June.

Newell was the band director from 1926 to 1942, and after hanging up his conductor baton, he taught shop and mechanical drawing until he retired in 1950. The *La Mezcla* that year was dedicated to him but made no mention of Newell starting the school's music program.

Yolanda Messer from the Class of 1942 was in the Armijo band in its early days. "I played violin for eight years in elementary school and then in high school Mr. Newell, our band instructor, taught me the French horn. I can't play either one anymore," Messer said. "We were never good enough to march, but we played at all the football games."

Armijo's first drum major was Class of 1954's Warren Sheldon, who had assumed the position the previous fall. In 1956, Robert O. Briggs took the helm as Armijo's band director for several years before leaving for what

The Armijo Super Band

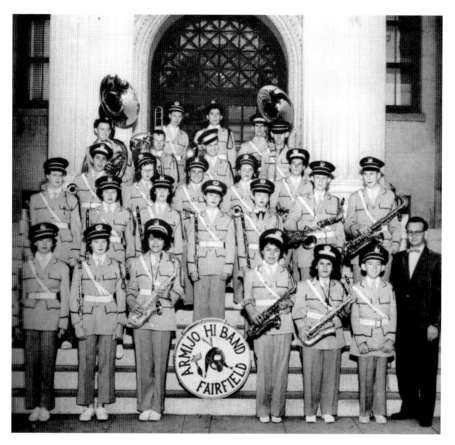

The 1955–56 Armijo band, under the direction of Bob Briggs, with an Indian symbol on the bass drum. *1956 Armijo High Yearbook.*

would be an illustrious career with the Cal Band. After retirement, Briggs formed the still active Solano Winds Community Concert Band in 1995.

Now, according to comic book mythos, what turned baby Kryptonian Kal-El into Superman were the yellow rays from our solar system's sun. According to local history, what turned the Armijo Band into the Armijo Super Band was the hiring of band director Ray Lindsey in 1968. Lindsey's attention to meticulous detail instilled in the band a culture, an identity and a winning tradition. Their rather braggadocious name was backed up by the "phat" trophy case that justified their swagger.

Lindsey graduated from the University of Montana in Missoula with bachelor and master of music degrees and taught at schools in the Bay Area and Las Vegas before coming to Armijo.

Armijo Super Band director Ray Lindsey and the band's logo. *Paul Castellano.*

The band had not exactly been slouches under Briggs and others, but under Lindsey's direction they attained new heights. An oft-repeated quote attributed to Lindsey is, "Why settle for mediocrity when you can be the best?"

Lindsey introduced the concept of Total Band Entertainment, which required buy-in from stakeholders throughout the Armijo community. The band was student-governed, the shows and much of the design for each performance came from students and they relied on parental support as fervent band boosters.

In 1969, the Armijo Band Boosters built a light stage they mounted in the school's gym for use in fundraising performances. That year, they featured songs from the rock musical *Hair*.

Lindsey was director of bands—plural—as there were numerous entities under the band umbrella. They included jazz band, concert band, Dixieland band, rock band, pep band and the big kahuna: the varsity or marching band that at times was approximately 150 members strong.

In the 1968–69 school year, Armijo claimed a ninth-place finish in their division at the All California Band Review in Long Beach, deemed the most prestigious review in the state, as seventy-five schools competed. It was the first time in many years they had had such a showing.

It was just the beginning.

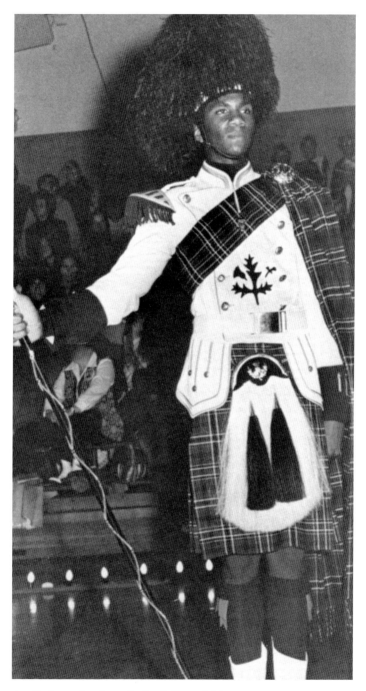

Armijo Super Band attached unit Drum Major Ken Johnson. *1974 Armijo High Yearbook.*

The first time the band was called the Super Band in the school yearbook, *La Mezcla*, was in 1972. Their accomplishments were piling up, and people began taking notice. In June 1972, the national band magazine *Ruffles and Flourishes* featured them and listed many of their accomplishments in competitions up to that point, including first-place finishes in Sacramento, Woodland, Cupertino, Merced, San Mateo and San Francisco.

The Super Band's repertoire included marching band staples like "Stars and Stripes Forever" and "Carmina Burana," as well as songs by then-contemporary artists like Chicago, Steppenwolf and Black Sabbath. In 1972, they came in third place in the All Western Band Review in Long Beach. Many band members celebrated by festooning Lindsey's car with toilet paper. In 1973, they finished in first place.

Their well-rehearsed precision in performance and musicality was becoming the stuff of legends, and they continued to wow up and down the state.

In addition to local parades and performances, they played at Disneyland and at the halftime of San Francisco 49ers games.

The pinnacle may have been January 1, 1976, when the Armijo Super Band marched in the eighty-seventh annual Tournament of Roses Parade in Pasadena, becoming the first Solano County band to do so.

Ray Lindsey moved on from Armijo in 1978 and left a legacy of greatness that endures to this day. In 2004, Louise Jacob, a 1991 alum of Fairfield High School and member of their band, the Scarlet Brigade, took over as director of the Armijo Super Band. Jacob is now the longest-serving director and not only continues their legacy but also has won more sweepstakes titles than her celebrated predecessor.

DEVADA RAMMELL: We took Grand Sweepstakes everywhere we went. We were definitely a force to be reckoned with.

JOYCE NAGEL JACKSON: Ray Lindsey taught me to be proud, not ashamed, of the fact that I was a "band geek." He taught me all about respect, hard work, sportsmanship, good musicianship and teamwork.

TAMARA ELLIOTT: It's absolutely unbelievable that we were children, led by a visionary, all working together to create something so magical. I wish all kids could experience what we experienced under Mr. Lindsey.

Terry O'Brien: I remember during practice when the band didn't play well, Ray Lindsey would say they could hear the sucking sound all the way down in the arts department. I also remember when I think perhaps the administration denied a request from Lindsey. He had us march through the halls of the school with the massive, mighty, deafening drum cadence playing. I'll never forget that. That's the kind of stuff that endeared Lindsey to us. He was so "outside the box." He was never the stereotypical school band instructor. He was the cool performer and always tried to put us first.

Chapter 7
ARMIJO SCHOOL NEWSPAPERS AND *LA MEZCLA* YEARBOOKS

The Evolution of the School Newspaper

The Armijo High School newspaper has a long history.

The first iteration was called the *Armijo Student* and debuted in 1905. It was a little booklet, and the inaugural issue featured fictional writing, ads for a livery stable and blacksmith shop and four pictures of the school, a wooden Queen Anne–style structure on Union Avenue.

While the topics covered in early newspapers were sporting events and other campus activities, from the 1930s through the 1950s, the major draw for students were gossip columns that reported, often with much hilarity (and invasions of privacy), who was dating whom. Students who two-timed others or found what they assumed was a secluded spot to make out often had it put in print for the entire school to read. The following examples are from 1944:

> *Lloyd Grotheer was gadding about chemistry with bright red lipstick all over his face. When asked how it got there, he answered, "Charlotte Gordon put it there." Say, Cha, I thought you knew they rationed that stuff. There's a war on you know?*
>
> *Seen going to the show last Saturday night was Chick "Wolf" Okell and Betty Harper. Backstabbing I think it's called.*

Armijo School Newspapers and *La Mezcla* Yearbooks

Left: A 1905 edition of the *Armijo Student*. Solano County Genealogical Society.

Right: The cover of the January 9, 1930 *Armijo Student*. Armijo Alumni Association.

Shirley Horgan! So we finally caught you! It seems several students saw Shirley and a well-known sailor parked in the dark after the reception Friday night. Danny, you shouldn't keep girls out so early in the morning!

Joyce Hopkins ought to be ashamed of herself...driving around the back roads with the lights off. Joyce says she and Leslie Banta were just scouting the country, but we know different, don't we? Lights out—back roads—Tsk! Tsk!

Collie Blossom was doing the gentlemanly thing by keeping Lois Mason's hands warm. I wonder if he noticed there was a basketball game going on?

The paper's name was changed to the *Armijo Scout* in the mid-1950s, and one feature was a weekly review of students' cars, which were identified as "Rods at Random" or "Classy Chassis." Some reviews were fawning, other were mocking, like this one about Sharon Arnold's 1951 Chevy: "The most miraculous thing about the car is the way it works. IT DOESN'T! The inside consists of pure plastic seat covers covered with Sid's hamburger crumbs, Coke and other beverages. The dash is complete with clock (removable), horn

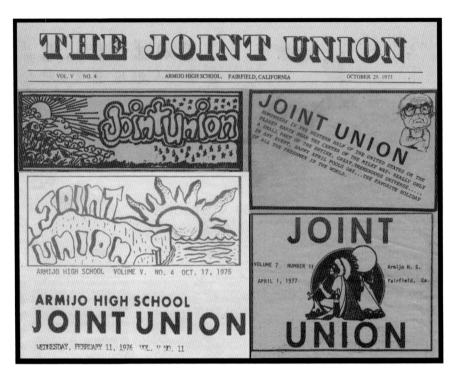

A collage of mastheads from the *Joint Union*. Tim Farmer collection.

(removed) and ashtray (won't open, use the floor). If anyone finds a Chevy key, please turn it in at the office, Sharon is tired of hot-wiring her little bomb."

In the 1970s and early 1980s, the newspaper's name was the *Joint Union*. It simultaneously gave a nod to the old name of the school and a not-so-subtle "wink, wink, nudge, nudge" to the dazed and confused marijuana culture back then.

The February 1973 *Joint Union* header is a case in point. It was an homage (or copyright-infringing rip-off) of Robert Crumb's famous, "Keep on Truckin'" cartoon, which was a favorite T-shirt image for '70s stoners.

An article titled "Mind If I Get Loaded?" from the May 14, 1971 *Joint Union* was one student's lament on then-strict marijuana laws. "As soon as our society finds a suitable drug to use in time of celebration, the government does their damnedest to choke our supply by declaring it against the law," it read in part.

A telling tagline in the paper was "A JOINT (union) A DAY KEEPS THE DOCTOR AWAY."

Armijo School Newspapers and *La Mezcla* Yearbooks

(front row) Virginia Reyes, Devin Loving, Mack King, Ana Lopez, Jean Summitt, Eddie Gibbons, Karen Johnson, Kenton Pfister, (back row) Tony Wade, Tracy Owensby, Stacey Owensby, Scott Blue, Chris Kelly

The 1979–80 *Joint Union* newspaper staff with advisor Mr. Greg Sullivan (*back row, right*). *1980 Armijo High Yearbook.*

This is not to imply that all of the staff were sitting around like Cheech and Chong all day. In fact, at least one *Joint Union* staff member in the 1970s, Maria White-Tillman, went on to work at several newspapers, TV news shows and then CNN.

A staff favorite over the years was the April Fool's parody issue. The 1977 version detailed, in graphic fashion, how some freshmen were supposedly murdered in the annex. Hilarity did not ensue from the administration. In 1982, the cover story in the April Fool's issue was about how the local McDonald's was honoring *Mommy Dearest* actress Joan Crawford with extremely cruel Happy Meal toys. While also in poor taste, compared to the 1977 feature, it was a Pulitzer Prize nominee.

While serious issues were discussed in Armijo school newspapers over the years, many were along the lines of 1975's "Barefootgate."

Darrell Anderson, a student and the son of a popular Armijo teacher of the same name, had issues with the school administration and expressed his frustration in a letter to the editor.

> *The bureaucracy at this school is incredible! I have been going to Armijo barefooted for two years and all of a sudden I'm sent home by [principal] Mr. Tucker for not wearing shoes. It seems impossible to me that my going barefoot could upset anyone. My feet don't smell and I don't kick dirt into*

anyone's face. Tucker is making a mountain out of this molehill of a breach of school rules. Every day there are other violations of the school dress code. For example, girls come to school without bras. I am certain no girl has ever been sent home for not wearing a bra. I am willing to sign a statement to the effect that I will not sue the school if I break my toe. Come on Tucker! Be realistic! We both know I'm not going to wear shoes except when you're around. As you said to me "I'm tired of playing games!"

Tim Gracyk wrote a snarky letter of support in a subsequent issue.

Darrell is a highly-disciplined student with a unique personality and a sharp wit who should be left alone. I think it should be pointed out that in the past three years the percentage of students dying from going barefoot has been low. Barney Rubble, the next door neighbor to Fred Flintstone for 5 years, was never seen wearing shoes and he was hardly on the 10 Most Wanted List! It has been proven that most people with venereal diseases wear shoes to school. Other reports show that older people suffering from rare gum diseases or hardening of the arteries wore shoes in their adolescent years. Statistics even show that most people who wore shoes in 1890 are now dead!

Over its long lifetime, the school newspaper's name changed numerous times and included the *Armijo Student*, *AUHS*, the *Armijo Scout*, the *Joint Union* and the *Arrow*. In 1996, it became the *Armijo Signal*.

Journalism teacher Lynne Herring started at Armijo in 1996 and shepherded the school newspaper's evolution from an analog, physical paper to a digital website (https://the-armijo-signal.com). "In 1996 it was all literal cut and paste. I would do the layout on great big grid sheets using rubber cement and take them to the *Daily Republic* to have them printed," Herring said. "Then it moved to a zip drive, then a flash drive and then I would just email the document as a PDF. Eventually the hassles with fundraising and the cost of paper became too exorbitant and the *Armijo Signal* became an interactive website."

Herring described fundraising as a "monster" when the paper was still physical, but now she has found that simply putting out a request to former students quickly results in the costs being covered and then some.

Herring's tenure as the advisor and teacher of the journalism class and, later, the journalism club, is easily the longest in Armijo history. One of the biggest challenges was keeping the *Signal* going through the COVID-19

pandemic. "I am a planner, so the year had already been mapped out. Some of those students that I had sent out on the last day before we closed were able to complete their assignments and submit them online, as we had been doing all year. Others were unreachable for a variety of reasons, or chose to write stories, but did not follow through," Herring said. "Despite the challenges, work was submitted, the editors were given their tasks and the newspaper was updated regularly."

Herring never intentionally courted controversy in the *Armijo Signal*, but sometimes it came a-calling anyway. "I once was called into the office because of a political cartoon we ran. It was about how there is no smoking allowed on campus, but the cartoon showed the teacher's lounge with smoke coming out of it," Herring said. "Evidently someone thought it was supposed to be marijuana smoke. That had never crossed my mind."

While yellowing copies of physical school newspapers can still be found among the memorabilia of Armijo alumni—or in Herring's garage—she is happy for the ubiquitousness of the internet. "Now if you Google something about Armijo High School, often a story from the *Armijo Signal* comes up, and that makes me proud."

Time in a Bottle: Looking Back at *La Mezcla* Yearbooks

The purpose of a high school education is to make life easier, richer, happier and most of all, to make good citizens. Students are trained not only in history, science and English, but also how to cooperate, how to conduct themselves creditably, how to lead better, fuller, and more useful lives.
—editorial in the 1921 La Mezcla

Some of the very first yearbooks in America date to the 1600s. With the exception of signatures from classmates, they bore little resemblance to what is now known as a yearbook. Obviously, photographs were not yet a thing, and what the yearbooks were most often used for was to keep mementoes like dried flowers, drawings and even locks of hair pressed within their pages.

In 1806, Yale University published what is generally regarded as the first college yearbook, but it wasn't published annually. The Massachusetts College of Pharma launched the first edition of the longest continuing yearbook, the *Signa*, in 1823. The first high school yearbook, Waterville,

New York's the *Evergreen*, went to print in 1845. It wasn't until 1880 that technological advances in printing made the mass production of yearbooks affordable that they really caught on.

Armijo's yearbook officially had its debut in 1912 and has always been known as the *La Mezcla*, which is Spanish for "the mixture." Well, sort of. Actually, from 1912 to 1915, it was named *La Mezclah*. Then, in the 1916 edition, an explanation was given as to why the name was changed. The editor wrote to the Spanish department at the University of California and asked if there was any authority for spelling it "Mezclah." They replied, "There is no authority whatsoever for writing 'Mezclah' as no Spanish words end in 'ah.'"

That was a rather inauspicious start, but in their defense, the first Spanish Club at Armijo didn't start until 1920.

The earliest Armijo yearbooks were very different from their hardbound, picture-driven descendants. The 1912 edition was in booklet form with a landscape orientation. While the paper is of high quality, the cover appears to have been just a slight step up from construction paper, which is why so many have survived with the pages intact but with tattered covers.

If the old saying that a picture is worth a thousand words is true, then the first yearbook proves it, as there are literally two photographs—of the track and field team and the sixteen graduating seniors—and probably at least two thousand words. The dominant feature for many years in the early Armijo yearbooks was a heavy focus on literary contributions from students.

At the time of Armijo's first few yearbooks, Fairfield was a very small farming community of about 850 people, most of them Caucasian, with a few Asians and Hispanics who mostly lived in the Suisun Valley. It wouldn't be until forty-five years later that significant numbers of African American students were represented in the pages of the high school annual.

The 1913 *La Mezclah* includes many of the same features as the first but also includes a troubling trend found in some of the earlier yearbooks: racism in the "jokes" section. It was the first time that the "n-word" was used in an Armijo yearbook but sadly not the last.

The senior class photos section of the 1914 yearbook included pictures of the graduates and much more. They had a class motto ("Out of School Life Into Life's School)," a class flower (the orchid) and class colors (purple and gold). Now, some may think, "Of course the class colors were purple and gold, those are Armijo's school colors." But later classes, like the graduates of 1918, chose their own class colors, which were blue and white.

Armijo School Newspapers and *La Mezcla* Yearbooks

That said, a poem called "The Purple and the Gold" by Ruth Roe was included in the literary section in the 1914 book, and it was sung at the laying of the cornerstone of the new high school building on April 3, 1914.

The 1914 athletic teams were represented with photographs and included baseball, track and field, boys' basketball and girls' basketball. The latter featured the team wearing ankle-length skirts, which may have hampered their shooting, as the reported scores against opponents from Vacaville, Dixon and Benicia were, respectively, 10–5, 5–4 and 2–0.

The 1930 yearbook was the first hardcover *La Mezcla*, and that edition is also particularly notable because it included the first appearance of the Block A Society, which was composed of the best athletes. A sophomore, junior or senior boy (yes, only males) must have fulfilled the requirements of earning the Block A in football, basketball, track, field or tennis and been recommended by the principal and coach for membership.

The 1929 Block A Society chose the Indian as Armijo's symbol. Interestingly, the first yearbook with an Indian on the cover and with Indian themes throughout was the 1924 edition.

On March 18 and 19, 1942, three months after the December 7, 1941 surprise attack on Pearl Harbor by the Empire of Japan, school pictures were taken for the 1942 *La Mezcla*. The significance of the dates is that a month earlier, on February 19, President Franklin Roosevelt signed Executive Order 9066 authorizing the evacuation of all persons deemed a threat to national security from the West Coast to relocation centers farther inland.

In the April 30, 1942 *Solano Republican*, it was announced that all alien and non-alien Solano County Japanese had to leave the county by noon on Sunday, May 3, 1942. In the 1943 yearbook, the only Asian students at Armijo are Chinese, not Japanese. It wasn't until the end of the war that Japanese students' faces were once again featured, in the 1946 edition.

From 1948 to 1961, many of the yearbooks featured padded covers, like the old-time keepsake baby books that were popular. By the early 1950s, the structural shift to the yearbooks being more picture-driven had taken place.

Sometimes, students have a myopic view of their time at Armijo and see their particular four-year journey as the only one there ever was. To wit, the 1952 *La Mezcla*, which breathlessly announced: "Here is something new in Armijo yearbook history! For the first time, we are using advertisements to help pay for the cost of publishing."

Uh, no.

The very first edition of *La Mezclah* and many after that had included advertisements. Now, what was different in the 1952 edition was that there

Armijo High School

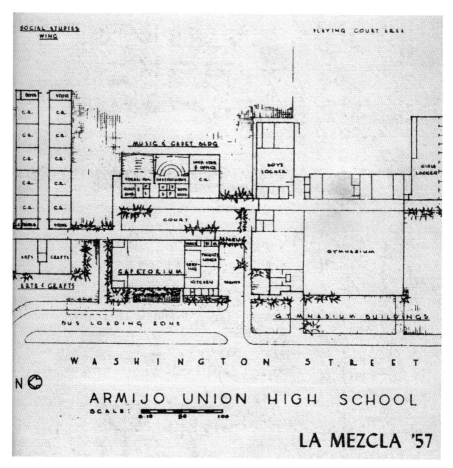

The cover of the 1957 *La Mezcla* with architectural plans for the new Washington Street campus. *1957 Armijo High Yearbook.*

were photographs of the businesses. They included the Sno-White (later the Sno-Man) Drive-In, which was just a hop, skip and a jump from Armijo on Union Avenue; Freitas Toggery, on Texas Street, where many Fairfield teens bought their Levi's jeans; and the popular hangout the Black Swan Restaurant and Lounge, on Highway 40.

The 1955 *La Mezcla* was the first to feature a black cover. The lettering appears to be silver, so if the Indian image in the lower right corner had been replaced by the Raiders' NFL logo, it would fit like a glove.

By the mid to late 1950s, Travis Air Force Base helped fuel a local population explosion, and it was obvious that Armijo had outgrown its Union Avenue building.

A new site for the Armijo campus was planned, approved and began construction in the late 1950s. The front and back covers of the 1957 *La Mezcla* show the blueprints for the new educational plant that was to be located on nearby Washington Street. The 1959 edition was the third and final yearbook to have a picture of the Union Avenue Armijo High building on its cover. It is a full cover shot with a school bus, perhaps signifying moving a block away to the school's new home.

By the way, Walsworth Publishing, the company that published the 1959 *La Mezcla*, gave its cover to every salesman throughout the United States to exhibit as an example of an outstanding yearbook cover.

The 1965 *La Mezcla* was an anomaly, as it was twelve and one-quarter inches long, as opposed to eleven inches. Starting with the 1986 edition, that size would become the norm, but at the time, the huge 1965 yearbook stuck out from its predecessors, which may have been the point.

The Class of 1966 had a novel idea: They published a separate summer supplement that covered year-end activities from March to June that were usually left out due to yearbook publication deadlines. Thus, action shots of baseball games and track meets, the Senior Tea and Banquet, Senior Skip Day and pictures from commencement were captured and shared.

The 1969 yearbook, along with the *La Mezcla* published a decade later, are the only two to feature an orange cover. The rather psychedelic yin-yang artsy drawing created by later Huey Lewis and the News member Johnny Colla was inspired by Fillmore and Avalon Ballroom concert posters.

Now, there have always been students at Armijo who bucked the rules and engaged in underage drinking. Whether it was out in the country in the old days or on the downtown cruise, it was usually an undercover activity. But the 1977 *La Mezcla* includes a two-page feature, "Heathen Habits," with pictures of beer, wine and champagne as well as marijuana pipes and bongs from Eucalyptus Records and Tapes. "The use of these substances ranges from the occasional user to the

The cover of the 1959 *La Mezcla*. *1959 Armijo High Yearbook.*

frequent and sometimes excessive user, otherwise known as a 'burn-out,'" a caption reads.

While styles changed over the years, many things remained relatively similar in the yearbooks. For example, the Sadie Hawkins Dance, where girls ask the boys to the dance, was a feature for decades. It became less like a barnyard event with participants sitting on bales of hay over the years, but the tradition of couples dressing identically continued.

The Senior Superlatives section, which featured graduating students who were "Most Likely to Succeed" or "Class Clown" or "Most Talented," remains a feature. It began in the 1952 yearbook, where it was called the "Senior Totem Pole" and featured "Most Intellectual," "Most Athletic," "Most Popular," "Most Attractive," "Best Voice" and "Shyest."

The 1985 edition included "Most Kind-Hearted to Animals," "Life in the Fast Lane" (a synonymous phrase for "burn-out," perhaps) and "Sportiest Car" (which probably should have been awarded to the students' parents, who more than likely actually bought their nice rides).

First appearing in 1924, an Indian symbol was used dozens of times on the covers of Armijo yearbooks. However, there was no one image that was ever seen as the "official" Indian symbol. The closest is arguably the cover of the 1987 *La Mezcla*. That image of a Native American man holding a feathered spear with a shield emblazoned with the name of the school was painted on the side of the gym in 1988, when Armijo was named a California Distinguished School.

The 1990 yearbook celebrated Armijo being honored by the U.S. Department of Education's National Blue Ribbon Schools Program. It recognizes public and private elementary, middle and high schools based on their overall academic excellence or their progress in closing achievement gaps among student subgroups. The last photo in the book is a picture of then U.S. president George Herbert Walker Bush with the printed inscription "To the students and faculty of Armijo High School, with best wishes, George Bush."

The school was on a roll and kept it going with the 1991 yearbook, which celebrated the centennial of Armijo with a special history section. It covered much of the top-line Armijo history items this book does: the first building, the new building, the 1929 fire and famous alumni like Pat Morita and Johnny Colla.

Armijo yearbooks took a quantum leap in 1998 with the introduction of a digital component: a CD-ROM full of images. Or, it is assumed there are images on it, as in 2023 it is hard to find a way to play such an obsolete data repository.

The cover of the 1987 *La Mezcla*, which was later the inspiration for the Indian painted on the side of the gym. *1987 Armijo High Yearbook.*

ARMIJO HIGH SCHOOL

Left: The 1998 *La Mezcla* was the first that included a digital component, a bonus CD-ROM. *1998 Armijo High Yearbook*.

Below: The board game box that contained the 2004 *La Mezcla*. *2004 Armijo High Yearbook*.

The 2002 edition, on the heels of the September 11, 2001 terrorist attacks, was dedicated to the soldiers and uniformed public servants who contribute to American freedom and safety. It featured a clear Plexiglas cover and came with a note on how to care for it, including not to drop, throw or leave it in direct sunlight, and suggested purchasing a protective slipcover for one dollar.

Gimmicks became the name of the game when it came to yearbooks of the early 2000s. The 2004 edition may win as best gimmick ever for an Armijo yearbook: a board game. The Game of Armijo not only was the theme, the yearbook also actually came in a cardboard box like a Milton Bradley board game. It listed ages fourteen to eighteen, allowed 2,265 players and boasted "100 years of student entertainment."

The 2007 yearbook featured an actual fabric letter *A* from an Armijo letterman jacket on the cover of each copy. Before the one-upmanship of the yearbook gimmickry reached the point where they would be scratch-n-sniff, glow-in-the-dark or come with built-in fireworks, subsequent classes decided to tone it down a little.

That said, the 2023 edition offered numerous extra features, for a price, including photo pockets, a clear protective cover, color autograph section and monogram on the cover with an icon. The Armijo Alumni Association, which purchases a yearbook each year, chose a mortarboard icon.

The back cover of the 2022 yearbook reads, "Thanks for the adventure, now go have a new one! Love, Armijo."

Chapter 8

THE ARMIJO CENTENNIAL AND THE ARMIJO ALUMNI ASSOCIATION

In the 1908 edition of the *Armijo Student*, an editorial lamented the difficulties in keeping up with past Armijo grads. "How much easier matters would be if there were an Alumni Association. We hope in the near future to see some organization," it read in part.

On April 28, 1956, more than 360 former Armijo High School students met in the Suisun Valley Farm Bureau (the white stucco building on Boynton Avenue with red Spanish mission tiles that was once Storer Cable TV). The sign-in sheet from the gathering features several recognizable local family names, including Glashoff, Neitzel, Wolfskill and Lambrecht.

The emcee was Ben "Chalky" Oliver, Class of 1927. The special honored guest was Richard Rush, then seventy-nine years old and one of the five students who had graduated in 1895, Armijo's third class. He was the oldest son of the late state senator Benjamin F. Rush (the prominent local family that founded Rush Ranch).

Longtime teachers were honored, and Bill Brownlee, the son of James Brownlee, Armijo's longest-tenured principal for whom the football field is dedicated, said how much his father would have loved to have been there.

Class of 1936 grad Walter "Red" Wright (who later wrote the book *Gravity Is a Push* and turned his Ohio Street home in Fairfield into a museum) was the general chairman of the dinner. The establishment of the Armijo Alumni Association was approved by the general membership present. Wright's classmate Harry Chadbourne briefly read the bylaws, and the group approved them. The Armijo choral group then sang a few selections.

The organization met again in 1957 and may have had future get-togethers, but eventually, they petered out.

> **WELCOME HOME**
> GRADUATES, FORMER STUDENTS, TEACHERS, FORMER TEACHERS, SPECIAL GUESTS
> AND OUR BABY ALUMNI CLASS OF 1957
>
> # PROGRAM
>
> **Master of Ceremonies**
> Ben (Chalky) Oliver............Class of 1927
>
> **Dinner Committee**
> Elsie TurriClass of 1918
> Marvel (Wright) Little.........Class of 1933
> Harry Chadbourne................Class of 1936
> Walter Wright Jr..................Class of 1936
> Barbara Baxter......................Class of 1939
> Helen Allen...........................Class of 1943
> Elaine (Serpas) Smith...........Class of 1947
> Arlene (Engell) Reynolds.....Class of 1947
> John LucasSuperintendent
>
> **Dance Committee**
> W. F. Newell, Teacher............Retired 1951
> O. C. Spohn, Teacher.............Retired 1956
> Eddie Hopkins, Teacher.........Class of 1934
>
> RECEPTION.....................6:30 to 7:30 p.m.
> BUFFET DINNER.............7:30 to 9:30 p.m.
> DANCING.................9:30 p.m. to 12:30 a.m.
>
> Scrolls Drawn By
> Jacquelyn Witt, Class of 1956
>
> NUMBER OF MY CLASS PRESENT WAS_____ NUMBER OF ALUMNI PRESENT WAS_____
>
> **DON'T FORGET THE DINNER AND DANCE NEXT YEAR AND BE SURE AND PASS THE WORD AROUND**

The program from the second annual Armijo Alumni Banquet in 1957. *Tim Farmer collection.*

Fast-forward to the late 1980s, when Armijo Class of 1971 grad Tim Farmer, a local historian and beloved teacher at his alma mater, realized Armijo's centennial was approaching. Farmer said in a newspaper account, "I thought it was a good idea to throw a party." He called up the aforementioned Ben Oliver, and they cofounded the Armijo Centennial Committee.

With the help of a $1,000 grant from the city of Fairfield Cultural Arts Department, the committee was launched, and several volunteers joined. The Centennial Committee's celebration of Armijo's one-hundredth birthday coincided with Fairfield's 1991 Fourth of July parade. They had a float and thirty to fifty cars representing different classes of alumni. Other events included a steak dinner and dance at the Cordelia Fire Hall and a golf tournament the following weekend.

At the committee's wrap-up meeting after all the festivities, Harry Chadbourne, who had read the bylaws at the 1956 event, gave a tearful plea for those involved to keep it going. Ruth Smith Hagemann, Class of 1933, stood and made the first donation of $100 for the advancement of the Armijo Alumni Association.

With the guidance of historian Bert Hughes, the Armijo Alumni Association formed and had its first meeting on July 16, 1991. The

Artist Daphne Wynne Nixon's painting of the Cordelia Fire House, where the Armijo Alumni Association held events for years. *www.daphnewynnenixonpaintings.com*.

founders were Elayne Serpas, Class of 1947; Jeannie Marianno, Class of 1948; David Marianno, Class of 1952; Kathy Downey, Class of 1958; Nanciann Gregg, Class of 1959; Gordene Pienovi, Class of 1960; and Tim Farmer, Class of 1971.

They met for a time at the Marianno's home and called themselves informally the Kitchen Cabinet Group. Annual fundraising events, most of which occurred at the Cordelia Fire Hall, raised money for scholarships and sometimes special projects like the rebuilding of the Armijo bleachers in 1994.

Steak dinners, pasta feeds and other fundraisers followed by fellowship and dancing among numerous generations occurred for years. In 2015, the Alumni Association created the Armijo High School Hall of Fame and had a dinner and induction ceremony at the Courtyard Marriott in Fairfield. In 2016, they held a benefit rock concert featuring, among other artists, the mid-sixties alumni band The Malibus.

In 2016, black mold was found in the firefighters' sleeping quarters at the Cordelia Fire Hall, and they were forced to move into the main hall, ending

outside rentals. The Alumni Association's dwindling board members had been running on fumes, with less and less participation, and for the most part called it quits. In 2023, they reformed to put on another Armijo High School Hall of Fame event at the Downtown Theatre in Fairfield.

To date, the Armijo Alumni Association has awarded more than $187,000 in scholarships and will continue to do so from the nest egg that has built up over the years.

Chapter 9

THE INDIAN SYMBOL

In the September 29, 1929 Armijo Hi News, a weekly feature in the *Solano Republican*, the headline read "Block A Society Decides on Name for Armijo Teams." The accompanying article read: "When the Armijo athletic teams trot on the field of battle in the future, they will go under the name of 'Indians.' This was decided at a meeting of the Block A Society last week. The name is particularly fitting to this section of the state as well as being a fighting cognomen for the Armijo teams. This action is an advancement for Armijo and displays the wonderful spirit that is being developed at the school."

Nearly ninety years later, in April 2019, the Fairfield-Suisun School District board voted unanimously to accept a mascot committee's recommendation that the Indian name be replaced.

The discussion about changing perceived offensive mascots had been raging nationally among organizations like the Washington NFL team (whose name was a racial slur) and locally as both Vallejo High and Napa High had been pressured to change theirs. I was not surprised when the discussion came to Armijo. I had heard all the arguments on both sides of the issue. In my view, legitimate reasons were raised to keep the mascot as well as to change it.

I know that to some it was offensive to have a human being be a mascot. I also know that there are other humans who are used as mascots. I know that many if not most alumni never thought of having an Indian as a mascot as humiliating but as a way to honor the Indigenous people of this continent.

The Indian Symbol

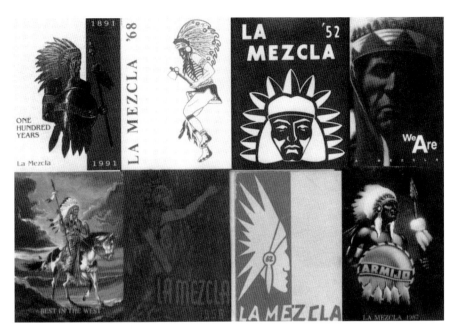

Some of the numerous *La Mezcla* yearbook covers that featured likenesses of Indians. *Tony Wade.*

I also know that there are very troubling images and cultural appropriation that went on over the years at Armijo that, regardless of intentions, were far from honoring.

While at Armijo back in 1957, Pizzarino Boy and artist Michael Green drew a picture of himself and his compatriots, including Pete Andronis, on the steps of the old school on Union Avenue (see page 113). He then thought it would be fun to draw his buddy Pete as an Indian. He doesn't recall exactly but probably drew it on a napkin or a piece of notebook paper, and it wasn't for anything official, just something he doodled. But that little doodle took on a life of its own.

A knockoff of his caricatured Indian showed up in the 1964 yearbook, and then in 1965 and other years it was actually used on the cover of the official Indian Student Guide given to parents and pupils at the beginning of the school year. It is still used by some classes from the 1950s and '60s for reunions, although the tomahawk he originally carried is now a cane.

In 2022, Green, then eighty-two years old, said that he definitely has empathy for people who thought it was wrong for Armijo to use an American Indian as a symbol. He never meant any harm by his cartoon. "I had never met an Indian until I went to college in Logan, Utah, which

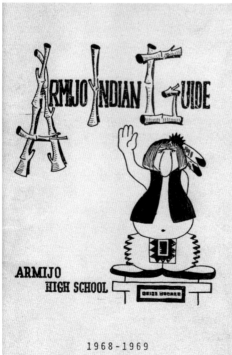

Above: Pizzarino Boy Gene Thacker (*standing*) holds the Indian caricature drawing that was created by Michael Green (*seated*). *Tony Wade.*

Left: The cover of the 1968–69 Armijo Indian Guide. *Tim Farmer collection.*

bordered a reservation. The only Indians I knew were ones from books like *Last of the Mohicans* or ones from movies and TV like Tonto from *The Lone Ranger*," Green said. "I had never seen an Indian that dressed just like me, talked just like me and bought groceries just like me until then. I had an immediate sense that all of the things I thought about American Indians were long, long past, and that they as a people were treated very poorly. We have come a long way from adolescent humor in the 1950s to the realities of today."

Armijo's ninety-year history with the Indian mascot has countless images that reflect the power, strength, resolve and grace of Native Americans. It also is replete with talk of "injuns," cultural appropriation and symbols that resemble the demeaning and now-abandoned Cleveland Indians mascot Chief Wahoo.

Those who make the argument that it was a symbol and not a mascot do have a point, as it is true that in the 1929 yearbook it was introduced as a symbol. However, there are plenty of examples in the historical record of it being called a mascot. In the 1961 *La Mezcla*, for example, the school mascot was a student who dressed up in a chief's costume, purple squaw dress or a warrior outfit with a large papier-mâché Indian head. In the yearbook, it was said that on the basketball court and football field she "stole scalps" and promoted goodwill. Her name? "Indy Ann."

I think it goes without saying that Native Americans, in general, face a variety of incredibly difficult challenges. The following is from U.S. Department of Health and Human Services' Indian Health Service webpage: "The American Indian and Alaska Native people have long experienced lower health status when compared with other Americans. Lower life expectancy and the disproportionate disease burden exist perhaps because of inadequate education, disproportionate poverty, discrimination in the delivery of health services, and cultural differences. These are broad quality of life issues rooted in economic adversity and poor social conditions."

This begs the question: How exactly does changing the mascot of a school help any of the actual problems that Native Americans face?

A scene from an episode of the TV show *The West Wing* called "A Proportional Response" comes to mind. In it, the White House chief of staff Leo McGarry, who is white, is talking to Admiral Percy Fitzwallace, Chairman of the Joint Chiefs, who is African American.

Leo McGarry: The President's personal aide. They're looking at a kid. You have any problem with a young Black man waiting on the President?

Admiral Percy Fitzwallace: I'm an old Black man and I wait on the President.
Leo McGarry: The kid's got to carry his bags and…
Admiral Percy Fitzwallace: You going to pay him a decent wage?
Leo McGarry: Yeah.
Admiral Percy Fitzwallace: You going to treat him with respect in the workplace?
Leo McGarry: Yeah.
Admiral Percy Fitzwallace: Then why the hell should I care?
Leo McGarry: That's what I thought.
Admiral Percy Fitzwallace: I got some real, honest-to-God battles to fight, Leo. I don't have time for the cosmetic ones.

So is the battle to get mascots changed a real battle or a cosmetic one?

Now, the natural counters to the "cosmetic vs. real battles" argument are that, number one, *The West Wing* was just a TV show, and number two, it was written by a white guy, Aaron Sorkin, literally putting words in an African American character's mouth.

Saying that changing the mascot helps absolutely no one might be belied by the well-known starfish parable. In it, a little boy at the beach is grabbing sand-stranded starfish and hurling them back into the sea. An old man says to the boy, "There's hundreds of them here! Do you really think you're making any difference?" The boy picks up a starfish, flings it into the water and says, "It made a difference to that one."

And it should be mentioned that the mascot issue is not just about someone getting their feelings hurt. One argument that has been used many times is to question all of the other instances that use the term *Indian* or related ones. What about Jeep Cherokees? Or the numerous cities, counties, states, bodies of water and other things named for Native Americans, not the least of which are Indian casinos? Are they all to be changed as well?

In 2005, the American Psychological Association pointed out a key difference: "The use of American Indian mascots as symbols in schools and university athletic programs is particularly troubling because schools are places of learning. These mascots are teaching stereotypical, misleading and too often, insulting images of American Indians. These negative lessons are not just affecting American Indian students; they are sending the wrong message to all students."

A comprehensive 2020 review of the psychosocial effects of Native-themed mascots revealed some of the negative psychological effects such

mascots wreak on the well-being of Native Americans, especially youth. They include low self-esteem, low community worth, increased negative feelings, stress and depression.

Someone might ask, "What about Native Americans who were not offended by the Indian mascot?" According to his son Johnny Finley, in the late 1970s and the 1980s, Bernard Finley, who many remember riding a motorcycle with a pink seat cover, taught Navajo rug weaving and bead work at both Armijo and Fairfield High. He was the Native American needs coordinator for the school district. Current Armijo multimedia instructor Anthony Gonzalez, whose ancestors are Mayan from Nicaragua and the Apache Nation, also had no problem with the Indian mascot.

Their feelings are valid, but others trotting them out as examples to bolster their position can sound a whole lot like someone defending, say, racist behavior toward African Americans by pointing to their sole Black friend.

And what about how the word *Indian* is used in Indian casinos and other place-names that are not in the same category as the ethnic slur that was the former name of the Washington Commanders?

Well, who gets to make that call? When I was walking through Lee Bell Park as a freshman, some punk with a bunch of other people drinking beer called me "spook." I'd never heard that word used as a pejorative before, and it is definitely not as bad as the "n-word," but I knew it was meant as an insult based on my color and did not like it.

Look, I could go back and forth with the point and counterpoint, but argument time is over. Those who wanted the mascot changed won. The Armijo Indians are no longer the symbol/mascot of the school and the Armijo Royals are now forging ahead with their own identity, culture and pride.

My personal opinion is that not everyone who wanted to change the logo is a lightweight who is too politically correct, and not everyone who wanted to keep it is an ignorant, uneducated racist.

The problem is, there doesn't appear to be any middle ground with those two groups. When I first saw the Armijo Royals logo, which features a lion with a crown, I thought, and still do think, that it looks pretty cool. I have shown it to other alumni who dismissed it immediately. In my view, they wouldn't like it even if it was a picture of themselves.

To me, the real tragedy with the changing of the mascot is that many alumni now feel completely alienated from their alma mater. Some want nothing to do with the school, which to me seems punitive to people who had no say in it and have no fault: the current students.

When I researched the early days of the Armijo Alumni Association, many of the people who attended events and provided money for scholarships for then-current students were graduates from the 1930s to the 1950s. That means they never actually attended the Armijo on Washington Street. To them, Armijo had been on Union Avenue. And yet they stayed true to their school.

I've tried to bridge the gap between the old alumni and the current school in creative ways. At the fortieth reunion of my class, 1982, I sold extra yearbooks the Alumni Association had and some Armijo Indians memorabilia. At some of my book signing events, I sold "Armijo Indians Forever!" T-shirts.

The Armijo Royals mascot. *Armijo High School.*

Those funds from Armijo Indians buying Armijo Indians merch and yearbooks featuring the Armijo Indians turned into scholarships that three Armijo Indians—myself, Nanciann Gregg (Class of 1959) and Rima Totah (Class of 1991)—then awarded to…Armijo Royals.

You know what? I think there is some middle ground. The Armijo Indian mascot was adopted in 1929, but the school colors go back probably to the very early days of the school in the nineteenth century.

The Armijo Indians' school colors? Purple and gold. The Armijo Royals' school colors? Purple and gold.

Can't we all just get along?

Epilogue
BEYOND POMP AND CIRCUMSTANCE

The bonds that are forged during the formative years when people are not quite children and not quite adults can, and sometimes do, last a lifetime. At numerous Armijo class reunions, classmates squeal in delight when their old high school partners in crime show up, and memories are stirred and friendships rekindled. The Class of 1942, for example, met annually up until their seventy-eighth (!) reunion in 2020. Two members from that class, Dorene Siebe Darville and Yolanda Elmo Messer, who were both ninety-six in 2020, met in line when they were registering for classes at Armijo in 1938.

However, for many people, high school was not a pleasant experience. Whether because of bullying, homophobic threats, teasing or just not fitting it, some former students couldn't wait to put Armijo in their rearview mirrors.

Graduation speeches often rightfully feature the theme of looking forward and meeting the challenges that the future holds as the high school chapter of students' lives ends. Moving the tassel on their mortarboards from right to left symbolizes that change, and after the hugs, tears, photos and high-fives, those challenges move to the front burner.

Armijo alumni have reached the pinnacles of success in many fields. Some have accumulated abundant material wealth, others not so much but are rich in other ways. Some have climbed to the top of the corporate ladder, only to discover that that ladder was leaning against the wrong wall. Some

Epilogue

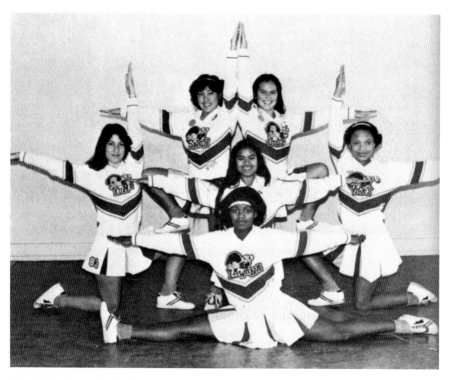

The 1981–82 Armijo Pep Squad. *1982 Armijo High yearbook.*

earned advanced degrees in college, some never went to college. But all had to somehow find their way in the larger world beyond the school campus.

As asserted in the preface, this book is *a* history of Armijo High School, not *the* history. Its pages are finite, but the individual stories of past students, teachers and faculty and all those they touched throughout their lifetimes are infinite. They are unique and varied, but all have a common denominator: Armijo High School.

Appendix A

WHO WAS YOUR FAVORITE TEACHER AT ARMIJO?

Jess Woodruff, Class of 1995: Herr Summers the German teacher was the best! He was funny and taught us insults!

Doug Rodgers, Class of 1974: My favorite was Mr. Scherr. He held the respect of students because he respected us as people. I believe it was the first time an adult ever called me Mr. Rodgers.

Science teacher Lloyd Wells gets elemental. *1985 Armijo High Yearbook.*

Appendix A

Some of the late 1950s Armijo staff. *From left to right*: Irene Delong, Miss Carol Peters, Robert Briggs, C. Eugene Smith, Nurse Virginia Arvin, Virginia Scardigli, Martina Flach-Winter and Genevieve Carlson. *Armijo Alumni Association*.

VANESSA WALLING-SISI, CLASS OF 1991: Jan Radesky. She dressed and acted like Julius Caesar and made us want to assassinate her by the end of the period. "Et tu, Brute?"

ANGELA McCALL, CLASS OF 1974: Mr. Regal, Algebra teacher. He was the oldest teacher at Armijo. He had a great sense of humor. To be able to make young people laugh and hold their attention at his age I thought was awesome.

ADAN LOPEZ, CLASS OF 2001: Man, that's a hard one. But I have three: (1) Mr. Blakesmith, because there were times during his history lessons where he would just sit there and talk about real life. It got deep sometimes. (2) Mr. Marciel, because that guy was real and funny. (3) Mr. Barney, because he never mispronounced my name since I'd known him as a substitute teacher up until he became an English teacher at Armijo, and I was impressed.

Appendix B

ODDS AND ENDS

In 1905, arrangements were made for a debate with Napa High School, but when Napa found out there was a girl on the Armijo team, they wanted her removed. When Armijo refused, they withdrew.

- The 1909 girls' basketball team, evidently new to the game, lost to Vacaville by a score of…wait for it…68–3.

- In June 1929, a seventeen-year-old female graduate of Armijo was going to elope with her fiancé in Reno immediately after receiving her diploma. Her fiancé was nineteen-year-old Fred Relyea, and he evidently had only enough money to get his betrothed to Reno, buy a license and pay the preacher—a graduation gift was not going to happen. But instead of telling his bride-to-be the truth, Relyea concocted a story that he had in fact bought his lady love a gold necklace but that he had been robbed. To add some believability to his lie, he parked at a desolate spot and deliberately shot off a part of his little finger. Under grilling from deputy sheriffs, Relyea confessed to his odd actions.

- In 1938, Jim Thorpe, sometimes called the world's greatest athlete, who played professional football, baseball and basketball and won two Olympic gold medals, made an appearance at the

Appendix B

Armijo Auditorium. Under the direction of their coach, Pop Warner, his collegiate team, the Carlisle Indians, dominated Ivy League schools like Harvard.

- In 1948, the legendary comedy duo Abbot and Costello, featuring straight man Bud Abbott and cutup Lou Costello, were scheduled to come to Fairfield for a fundraiser for the Lions Club that included an appearance at an Armijo football game and a show at the Fairfield-Suisun Air Force Base (now Travis AFB). Unfortunately, only Costello came, as Abbott was ill.

 The local paper reported: "Mr. Costello and his troupe landed at the Air Base shortly after three o'clock yesterday and he was whisked to the Armijo football field in local cars led by police chief Rex Clift. Here, Mr. Costello was given a rousing ovation by the huge crowd and was cheered when he volunteered to hold the ball for the kickoff for the second half of the game. With Mr. Costello acting as master of ceremonies the great show at the air base starting at 8 o'clock held and thrilled the huge crowd until midnight."

- In 1975, there was a Butcher's Lab Regional Occupational Program on-site at Armijo for students who wanted to pursue careers as butchers. They raised their own animals, paid for their feed and butchered the animals. It was later shut down after complaints from a butcher's union.

- In 1979, several Oakland Raiders players accepted the challenge from a local all-star team to play a charity basketball game at Armijo's E. Gary Vaughan Gymnasium. They included wide receivers Morris Bradshaw and Cliff Branch, cornerback Willie Brown, defensive end John Matuszak and safety and offensive tackles Art Shell and John Vella.

 The Raiders had stomped the Fairfield All-Stars, 81–60, the previous year. The 1979 local team included Fairfield High hoopster/Armijo Hall of Fame coach Jay Dahl, City Councilman (and later mayor) Chuck Hammond and Armijo hoops standout/Fairfield-Suisun School District teacher and administrator Mark Dietrich, among others.

Odds and Ends

An illustration by Danny Boy from Danielle Marinovich's 2005 book *The Book about Betty*. *Danielle Marinovich.*

The Raiders squeaked out a win over the Fairfield squad, 72–71. A picture in the *Daily Republic* showed six-foot, nine-inch Jay Dahl attempting to block a jumper by six-foot, eight-inch John Matuszak.

- In 1996, Vice President Al Gore visited Armijo. Principal Rae Lanpheir had to agree to install a U.S. Secret Service tracing device called a telephone trap.

- In 2005, Class of 1983 grad Danielle Marinovich wrote *The Book about Betty*. The book is about not judging people by how they dress, their ethnicity or other external factors. The story was based on Danielle's experiences being teased while attending Armijo. While it is ostensibly a children's book with illustrations and Dr. Seuss-esque rhymes, *The Book about Betty* resonated with many adults. A woman who had been ostracized because she was Jewish when she was a U.S. Navy lieutenant during World War II was brought to tears after reading it.

- According to Brad Burzynski, the choices for Armijo's new mascot came down to the Royals and the Ravens. Had the latter been chosen, the nameless football rivalry game with Fairfield High could have been called the Bird Bowl.

Appendix C
ARMIJO HIGH SCHOOL TIMELINE (NOT ALL-INCLUSIVE)

1891: Armijo Union High School opens and meets upstairs in Crystal Elementary School. The curriculum includes Latin, English, history and mathematics.

1893: A wooden Queen Anne–style structure located on Union Avenue in Fairfield becomes the first Armijo High School building. The first graduating class, consisting of just four students, received their diplomas that year.

1915: The new Armijo Union High School (which became the Solano County Hall of Justice in 1970) opens.

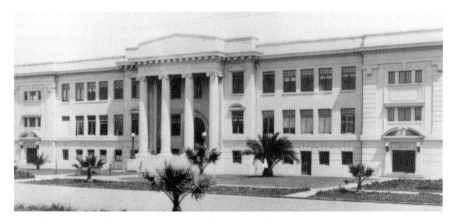

The 1915 Armijo High School building. *Tim Farmer collection*.

Appendix C

1928: Minnie Meyer, Class of 1928, breaks the women's world record in the 100-meter dash at 12.03 seconds.

1929: A devastating fire in the library causes extensive damage to the school.

1932: Class of 1917 grad Ernest Crowley, blinded in a duck-hunting accident as a boy, is elected to the California Assembly, where he serves until his death in 1952.

1953: Mike Diaz, Class of 1953, sets state basketball records for points in a game, points in a season and points in a career, all of which remain city records.

1955: Armijo's football field is dedicated to James Brownlee, the school's longest-tenured principal.

1956: Teacher Ivan Collier starts Armijo's Cadet Corps, predecessor of the Armijo Air Force Junior Reserve Officers Training Corps (AFJROTC).

1957: The first homecoming takes place at Armijo.

1961: The new Armijo campus on Washington Street is officially dedicated.

1964: The Class of 1964 donates the Senior Patio.

1964: Armijo Vice-Principal Sam Tracas becomes the first principal of the new Fairfield High School.

1968: *Vincebus Eruptum*, the debut proto–heavy metal album from psychedelic rock group Blue Cheer featuring Class of 1965 grad Leigh Stephens on lead guitar, is released.

1969: The Armijo Swim Center opens.

1972: Fairfield Elementary School becomes the Armijo Annex (Wings E–H).

A painted sign on the wall above the water fountains near the cafeteria signifying it was "spirit juice." *1979 Armijo High Yearbook.*

Left to right: Jackie Day, Adrienne Harris and Francine Mitchell on the Black Student Union homecoming float. *1974 Armijo High Yearbook.*

Appendix C

The quad at Armijo in 2022. *Tony Wade*.

1972: The gymnasium is dedicated to Class of 1959 grad and Armijo teacher/coach E. Gary Vaughn, who died that same year.

1973: West Texas Street Park is renamed Allan Witt Park after Class of 1931 grad Allan Witt, a Fairfield barber for nearly seven decades, a city councilman for twenty-four years and a mayor.

1975: Michael Burgher, Class of 1975, sets a state record for wrestling wins at sixty-six.

1975: Coach Ed Hopkins, Class of 1933, retires after coaching basketball at Armijo for thirty-five years.

1980: Armijo Class of 1964 grad Candace Lightner founds Mothers Against Drunk Driving (MADD) after her daughter is killed by an intoxicated driver.

1980: Phillip Glashoff, Class of 1969, teaches himself to turn scrap metal into colorful, whimsical art that is now admired around the world.

Armijo High School Timeline

1981: The annual Bowen Lectures, still held each fall at the University of Berkeley, begin in honor of internationally known mathematician and Class of 1964 grad Robert "Rufus" Bowen, who died in 1978.

1982: Doug Martin, 1976 grad who was drafted by the Minnesota Vikings in 1980 in the first round, is selected to the NFL Pro Bowl.

1983: Huey Lewis and The News, featuring saxophonist / Class of 1969 grad Johnny Colla, release the multiplatinum album *Sports*. It sells over ten million copies and includes hits like "Heart and Soul" and "I Want a New Drug."

1984: Class of 1952 grad James Harper is sentenced to life in prison for selling Minuteman missile secrets to the Soviet Union. Harper was paroled in 2016 and died in 2022.

1984: Class of 1949 grad Nori "Pat" Morita is nominated for a Best Supporting Actor Oscar for his role as Mr. Miyagi in *The Karate Kid*.

1987: Class of 1970 grad George Martin makes a pivotal sack on Denver Broncos quarterback John Elway, helping his team, the New York Giants, win Super Bowl XXI.

The football given by the NFL in 2014 to Armijo, now in a trophy case in the library, in honor of George Martin's Super Bowl victory. *Tony Wade*.

APPENDIX C

Class of 1982 grad Vic Agnello, who later became a doctor, was the drummer for pioneering Bay Area thrash metal band Làáz Rockit. *Tony Wade.*

A school bus takes students home after a day at school. *1982 Armijo High Yearbook.*

Armijo High School Timeline

1988: Armijo is chosen as a California Distinguished School.

1989: Pioneering Bay Area thrash metal band Làáz Rockit, featuring drummer and Class of 1982 grad Vic Agnello, who later became a doctor, has a video premiere on MTV's *Headbangers Ball*.

1991: Class of 1979 grad Jim Inglebright participates in his first NASCAR race.

1992: Ramona Garrett, Class of 1970, becomes the first woman and the first African American appointed to serve as a Solano County judge.

1993: Class of 1983 grad Steve DeVries achieves no. 18 rank in the world for doubles tennis.

1993: Greg "Huck" Flener, Class of 1987, plays his first Major League Baseball game, pitching for the Toronto Blue Jays.

1997: Foothill Parkway/Expressway is changed to Manuel Campos Parkway to honor Class of 1939 grad Manuel Campos, who owned the downtown Food Fair and seven other markets in Solano County as well as being a city councilman and mayor.

1998: Fairfield High School's gymnasium is named after longtime Falcons basketball coach and Armijo Class of 1950 grad Ron Thompson.

1999: Class of 1957 grad Emil Bautista becomes a ninth-degree Kajukenbo Grandmaster.

2000: Former Fairfield city councilman Garry T. Ichikawa, Class of 1965, is appointed a Solano County Superior Court judge.

2001: Armijo becomes a closed campus.

2001: The International Baccalaureate program begins at Armijo.

Appendix C

2003: Metal sculptor and Class of 2002 grad Chad Glashoff, along with his friend Alex Ross, accept a commission from the City of Fairfield to build the Centennial Windmill, which sits in the quad of the Fairfield Civic Center.

2006: Armijo first dips its toes into online social media with its own Myspace page.

2007: Twenty-one-year-old Matt Garcia, Class of 2004, becomes the youngest Fairfield City Council member ever elected.

2008: Following the death of his friend and City Councilmember Matt Garcia in September 2008, former Armijo principal Rick Vaccaro is appointed to the Fairfield City Council the following month.

2009: Class of 1992 grad Dae Spering launches Fairfield's award-winning Missouri Street Theatre. In addition to the adult theater company, the venue features a children's program, which educates hundreds of young people in the dramatic arts.

2009: President Barack Obama nominates Class of 1964 grad Robert Hale as undersecretary of defense (comptroller).

2011: Armijo's new $4 million Library and Media Center is unveiled.

2011: The first Armijo Senior Sunrise event takes place.

2011: Class of 1986 grad Mike Papadopoulos is named ESPN's Cal-Hi Sports State Coach of the Year for the Vacaville Bulldogs.

2012: Class of 1983 grad Jim Bowie, who was called up by the Oakland A's in 1994, has his number 33 jersey retired at Armijo.

2012: Class of 2012 grad Aaron Beverly becomes the Northern California Regional Golf Champion.

2013: For her decades of dedication, Class of 1959 grad Nanciann Gregg is given a tiara and sash and honored as "Miss Armijo

Armijo High School Timeline

Left: Armijo Alumni Association cofounder Nanciann Gregg next to the Centennial Windmill created by her grandson, Class of 2002 grad Chad Glashoff. *Tony Wade*.

Below: The interior of the current Armijo library. *Tony Wade*.

Appendix C

High School" at a fundraising dinner of the Armijo Alumni Association, which she cofounded.

2013: Class of 1990 grad David Meny, a digital artist supervisor at Industrial Light & Magic who contributed to the three Star Wars prequels and many other films, wins a Video Effects Society award for his work on the Marvel film *The Avengers*.

2014: Phaedra Ellis-Lamkins, Class of 1993, becomes the manager for legendary musician Prince and helps him win a years-long battle to secure ownership of his master tapes from Warner Bros.

2014: Armijo's new administration building opens.

2015: The Armijo Alumni Association creates the Armijo Hall of Fame and inducts twenty-seven individuals into the inaugural class in a sold-out event at the Courtyard Marriott in Fairfield.

2016: The Armijo Alumni Association celebrates Armijo's quasquicentennial (125th anniversary) with a fundraising concert called "Armijo Rocks," featuring 1960s classmates/band The Malibus.

2016: The Vacaville Heritage Council adds digitized copies of Armijo *La Mezcla* yearbooks to its website.

2017: Sheila Smith becomes Armijo's first female principal.

2017: Solar panels are installed in the student parking lot.

2019: Armijo retires the Indian symbol, adopted in 1929, to become the Armijo Royals.

2019: The Indian on the side of the gym facing Texas Street is painted over.

2020: Graduation ceremonies take place online due to the COVID-19 pandemic.

Left: An image of musician Prince painted on a wall. Class of 1993 grad Phaedra Ellis-Lamkins was once his manager. *Public domain.*

Right: Class of 2017 grad Luis Grijalva at the 2020 Summer Olympics (held in 2021 because of COVID-19) in Tokyo. *Bob Ramsak https://bit.ly/BobRamsak.*

2021: Charleston Brown becomes Armijo's first African American principal.

2021: Runner Luis Grijalva, Class of 2017 and a Deferred Action for Childhood Arrivals (DACA) recipient, finishes twelfth in the world in the men's 5,000-meter final, running for Guatemala at the Tokyo Olympics.

2021: Class of 2004 grad Frank E. Abney III, writer/director/animator on numerous films, including *Frozen, Big Hero 6, Coco, Incredibles 2, Toy Story 4* and *Soul,* is honored with the first NAACP Image Award for Outstanding Animated Short for Netflix's *Canvas,* which he wrote and directed.

Appendix C

2021: The first *La Mezcla* is published with the school mascot as the Armijo Royals.

2023: The Armijo Hall of Fame is resurrected and inducts twenty-two individuals as well as three families as generational inductees.

2023: *Armijo High School: Fairfield, California*, a history book about the school, is published by The History Press.

Appendix D

THE ARMIJO HIGH SCHOOL HALL OF FAME

Inaugural Inductees, 2015
Jose Francisco Armijo*
The cofounders of the Armijo Alumni Association
Darrell Anderson, teacher
Virginia Arvin, nurse*
Robert Briggs, band instructor*
James Brownlee, principal*
Doug Butt, coach*
Guido Colla, Suisun City mayor
Johnny Colla, musician
Ivan Collier, teacher*
Ron Cortese, coach
Jay Dahl, coach, athletic director
Gary Falati, mayor of Fairfield
Tim Farmer, teacher*
Matt Garcia, Fairfield city council member*
Phillip Glashoff, artist
Ed Hopkins, coach*
Rae Lanpheir, principal
Candace Lightner, founder of Mothers Against Drunk Driving (MADD)
Ray Lindsey, band director
Rebecca Lum, teacher, coach
George Martin, NFL football player

Appendix D

Nori "Pat" Morita, actor*
Alex Scherr, teacher
Dr. Sam Tracas, vice-principal
E. Gary Vaughn, teacher, coach*

2023 Inductees
Carrol "Buck" Bailey, coach*
Sr. Grand Master Emil Bautista, martial artist*
Robert "Rufus" Bowen, mathematician*
Michael Burgher, wrestler
Assemblyman Ernest Crowley, lawyer, politician*
Mike Diaz, basketball player
Gregory "Huck" Flener, MLB pitcher
Bill Fuller, coach*
Judge Ramona Garrett
Michael Green, artist
Jim Inglebright, race-car driver
Peggy Linville, coach
Dave Marshall, coach
Doug Martin, NFL player
Barbara McFadden, actress, singer, director
Nelda Mundy, teacher*
Dan O. Root II, teacher, superintendent*
Virginia Scardigli, teacher*
Ron Thompson, coach*
Bud Tonnesen, athlete
Maria White-Tillman, journalist
Allan Witt, mayor, youth advocate*
Generational inductees: the Engell Family, the Lanza Family, the Ramirez Family

posthumous inductees

Appendix E
ARMIJO HIGH SCHOOL PRINCIPALS

1891–1894	J.A. Metzler	1963–1969	Dasil Matthews
1894–1901	Chester Wetmore	1969–1977	Gene Dillman
1901–1904	O.F. Barth	1977–1979	Ken Sutton
1904–1907	H.F. Sheldon	1979–1981	Ken Perkins
1907–1911	E.F. Dyer	1981–1985	Larry Maniscalco
1911–1915	Irwin Passmore	1985–1992	Leo Petty
1915–1919	William Mackay	1992–2002	Rae Lanpheir
1919–1921	R.W. Everett	2002–2006	Rick Vaccaro
1921–1946	James E. Brownlee	2006–2009	Steven Peters
1946–1951	Harry Wiser	2009–2017	Eric Tretten
1951–1955	Loren Wann	2017–2021	Sheila Smith
1955–1957	John Lucas	2021–2022	Charleston Brown
1957–1963	C. Gene Smith	2022–present	John McMorris

BIBLIOGRAPHY

Books

Goerke-Shrode, Sabine. *Images of America: Fairfield.* Charleston, SC: Arcadia Publishing, 2005.
La Mezcla. Armijo High School. Fairfield, CA: various years.

Websites

Ancestry.com. https://www.ancestry.com.
Brainy Quote. https://www.brainyquote.com.
Historical Articles of Solano County Online Database. http://www.solanoarticles.com.
"I Grew Up in Fairfield, Too." Facebook group. https://www.facebook.com/groups/fairfieldyears.
Newspapers.com. https://www.newspapers.com.

Newspaper

Solano Republican/Daily Republic microfilm. Fairfield Civic Center Library.

ABOUT THE AUTHOR

Armijo Class of 1982 grad Tony Wade came to Fairfield in 1976, when he was twelve years old, and never left. In 2006, Wade began writing columns for the local newspaper the *Daily Republic* as a freelance writer.

Three of Wade's four brothers graduated from Armijo: Orvis Jr. (1977), Kenneth (1979) and Kelvin (1984). Youngest brother Scott is the only one to graduate from crosstown rival Fairfield High (in 1988), and he has been appropriately ostracized ever since. Not really.

In 2011, Wade became an accidental historian when he began writing his Back in the Day columns, which he describes as "kinda, sorta about local history."

Wade's first book, *Growing Up in Fairfield, California*, was published in 2021, and his second, *Lost Restaurants of Fairfield, California*, was published in 2022, both by The History Press. While neither were *New York Times* number one bestsellers, they both were North Texas Street number one bestsellers, which is close enough.

He lives in Fairfield with his wife, Beth, and their Chiweenie, Chunky Tiberius Wade.

You can reach Tony Wade at toekneeweighed@gmail.com.